IMAGES
of America

CALEDONIA
COUNTY

IMAGES
of America

CALEDONIA
COUNTY

Dolores E. Ham

ARCADIA
PUBLISHING

Published by Arcadia Publishing
Charleston SC, Chicago IL, Portsmouth NH, San Francisco CA

Printed in the United States of America

Library of Congress Catalog Card Number: 00106496

For all general information contact Arcadia Publishing at:
Telephone 843-853-2070
Fax 843-853-0044
E-mail sales@arcadiapublishing.com
For customer service and orders:
Toll-Free 1-888-313-2665

Visit us on the Internet at www.arcadiapublishing.com

*To my mother, Marie T. Maynard
(September 10, 1930–September 10,1994),
who always wanted to write a book,
I dedicate this book with love in her memory.*

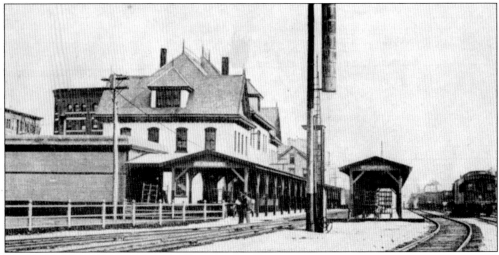

The Boston and Maine Railroad station in St. Johnsbury is one of many that connected towns in Caledonia County with other towns and cities. Many of the railroads are still used today for transporting freight.

CONTENTS

ACKNOWLEDGMENTS

Many individuals contributed the photographs, picture postcards, and newspaper articles that make up *Caledonia County*. For all their assistance and contributions I am very grateful. Special thanks to my family for sparing me all the time needed to work on this book and also to Harman Clark for donating his time to scanning the pictures for this publication.

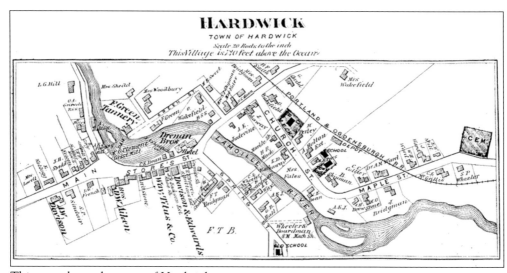

This map shows the town of Hardwick.

One

HARDWICK, WALDEN, AND DANVILLE

Hardwick

In 1788, a year after the arrival of Captain Bridgman, Thomas Fuller arrived in town with his wife and nine children. His 24-square-foot log house was shared for six months with William Cheever, whose family also numbered 11. Another early settler was Col. Alpha Warner, a native of Hardwick, Massachusetts, who came in 1796. For more than 50 years, he operated a tavern on the Hazen Road. (Hardwick photographs courtesy of Margaret Speir from the Hardwick Historical Society.)

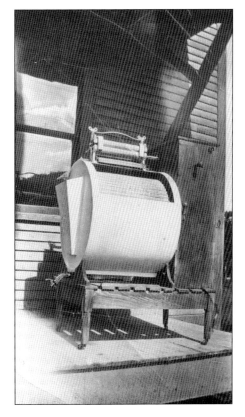

The washing machine was reportedly invented by Guy Shepard in Hardwick, Vermont. It certainly has come a long way from this early model.

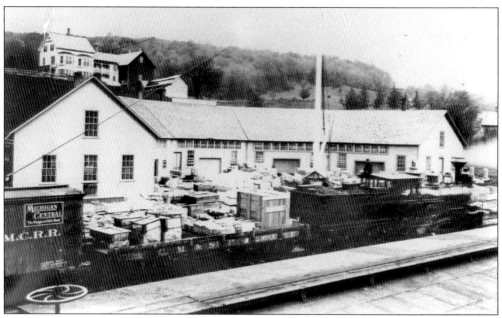

Many granite quarries were once in operation. Shown are several tons of granite being hauled on the quarry train by Hardwick and Woodbury Railroad in Hardwick.

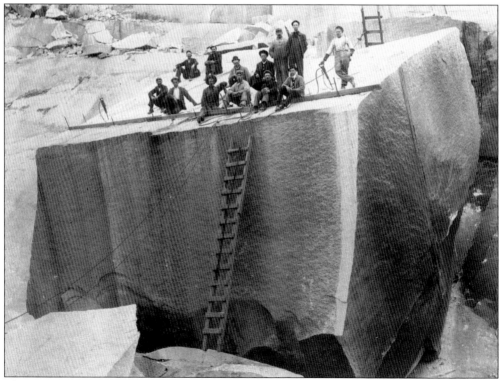

This is one example of the huge granite blocks that were removed from the quarry in Hardwick—no easy task in the 1920s and 1930s.

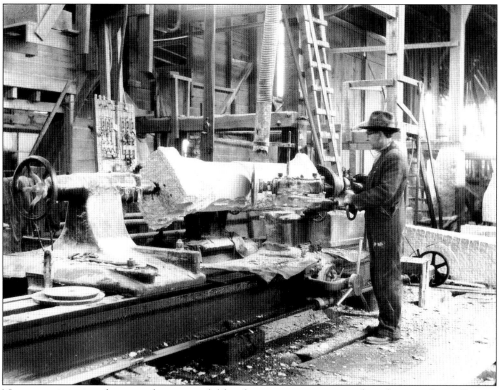

Not many interior photographs are available of quarrying operations, but this one shows George Stevenson, an employee of Woodbury Granite, working at the lathe.

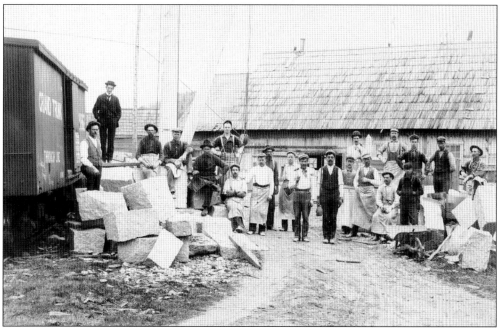

Shown is a typical day for hardworking crews loading granite to be shipped by railway to other parts of the country.

Employees of the Lamoille Valley Creamery in East Hardwick pose in 1912. A Mr. Jennings was the first to operate the creamery.

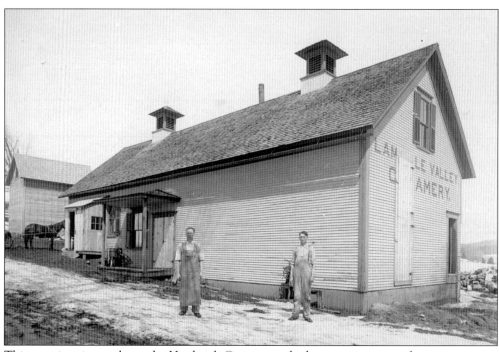

This exterior picture shows the Hardwick Creamery, which was in operation for many years.

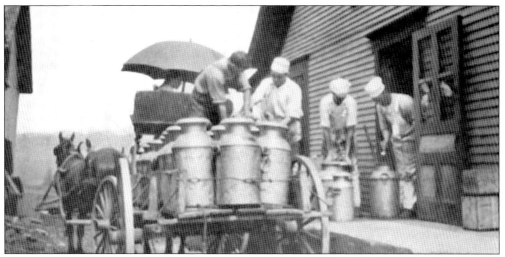

Loading large cream cans onto the wagon are Israel Domey, Fred (Brownie) Fay, and Bert Jennings for the Lamoille Valley Cooperative Creamery.

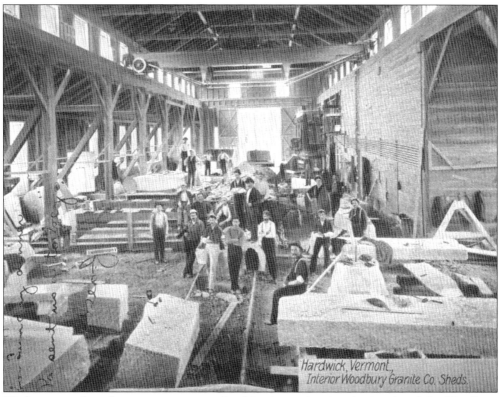

Workers pause for a few moments to pose for this picture showing the interior of the Woodbury Granite sheds in Hardwick. It looks like a dangerous place to work with such heavy-looking slabs.

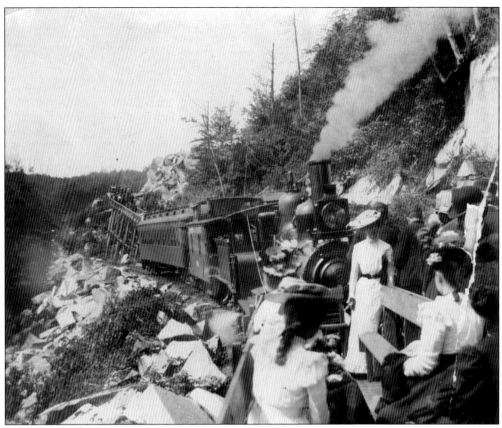

Occasionally the quarries were opened to the public. On this particular day, these ladies have arrived by railway to visit the granite quarry.

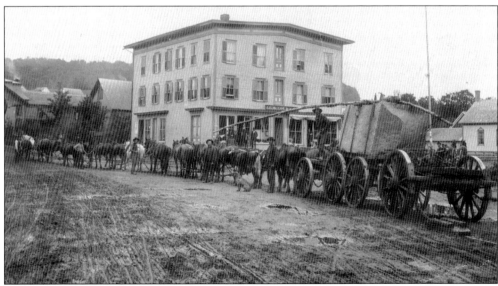

How many horses and oxen does it take to move a giant block of granite? The J.H. McLoud building in the background was designed by world-famous architect Lambert Packard, c. 1894.

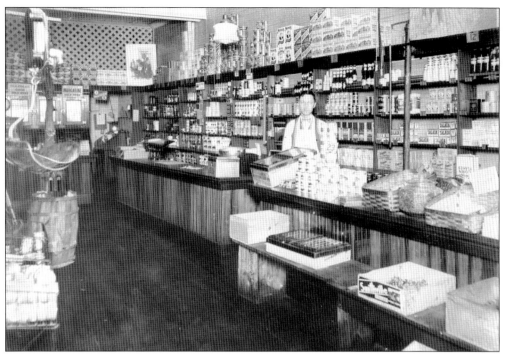

This view shows the interior of an early general store where just about anything could be purchased. Notice how neatly everything is stacked.

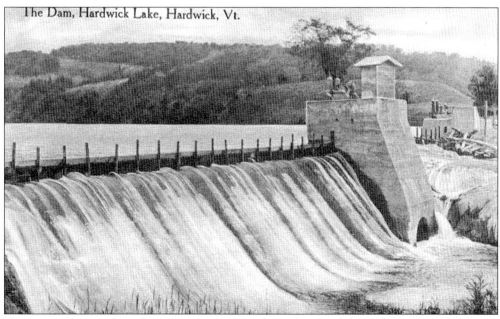

Waterpower was used much more extensively in the early part of the 20th century. The dam in Hardwick is no exception.

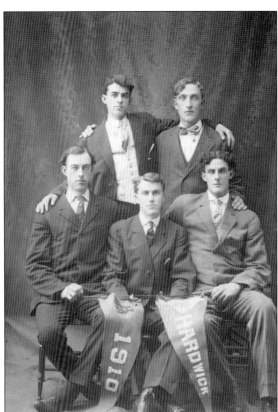

Sports were a very important part of recreation in the early 20th century. This 1910 team from Hardwick was one of many examples of athletes of the day.

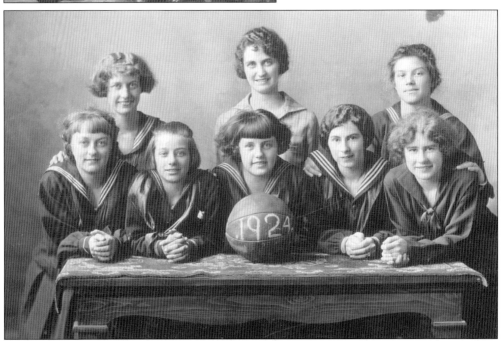

A rare sight is a female sports team from the early 1900s. This girls' basketball team from Hardwick in 1932 probably enjoyed the game as much as their male counterparts.

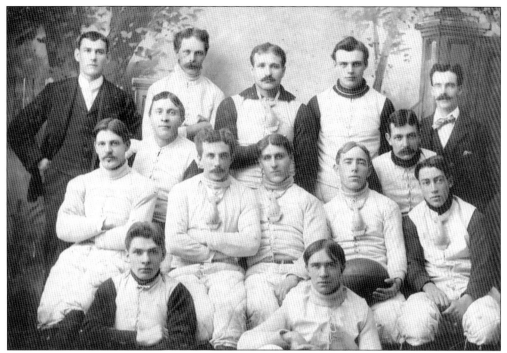

This 1899 football team from Hardwick probably sustained a few injuries without all the protective gear that athletes wear today.

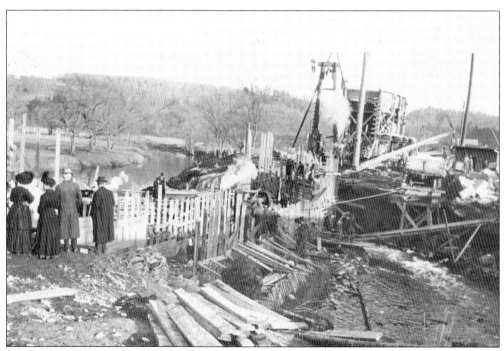

This bridge was completed in 1912. The dam is by the Jackson Bridge on Hardwick Lake, a man-made lake dammed up for an electric plant in Pottersville. Just a few houses remain there now.

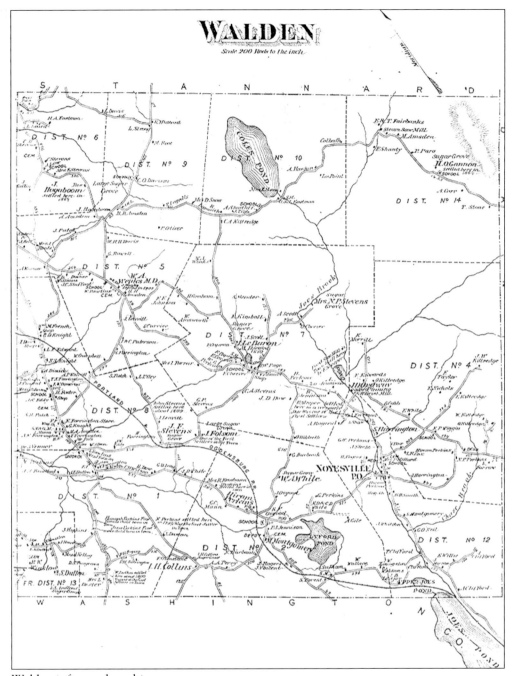

Walden is featured on this map.

Walden

The blockhouse on the Bayley-Hazen Road was located on the Perkins farm. It was here that Elder Chapman preached the first sermon in 1794 and where Nathaniel Perkins conducted the first school about two years later. The town was organized on March 24, 1794, with Lyman Hitchcock as moderator and Nathaniel Perkins as town clerk. Nathan Barker, Nathaniel Perkins, and Joseph Burley were selectmen. Samuel Gilman was the treasurer, and Elisha Cate served as the constable and collector. Perkins was chosen as the first representative in 1795.

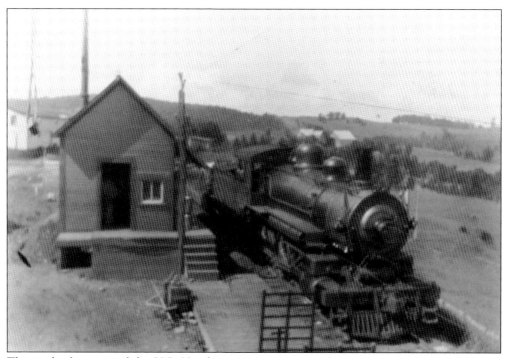

This is the location of the H.P. Hood receiving station at the creamery at Walden Heights. Diesel locomotives replaced steam in 1948. (Walden photographs courtesy of Betty Hatch, the Walden Historical Society.)

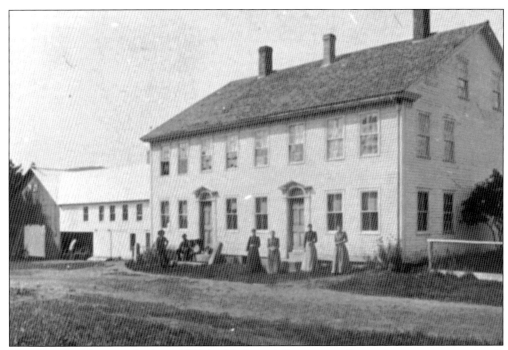

This large building was built in 1779 by Nathaniel Farrington. Successive owners were Jacob Dutton (1853–1863), J.M. Bradford (1863–1870), and A.E. Dutton. During these years, it remained a hotel with horse sheds for the teams and a dance hall in the connecting ell. It was later owned by E.T. Goodenough in 1887 and was passed to his son, Roy Goodenough, and then to Wilfred and Francese Cochran.

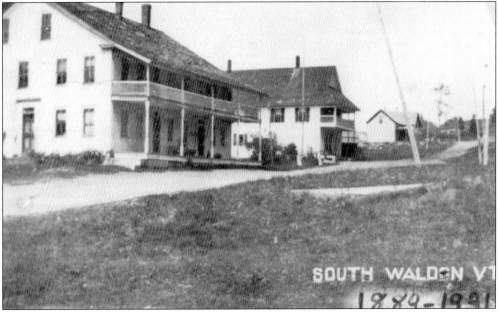

This view shows the hotel with the store and the John Stewart House. The McKeen House is in the background near the church. The church and the Chase House do not appear because of the Stewart House.

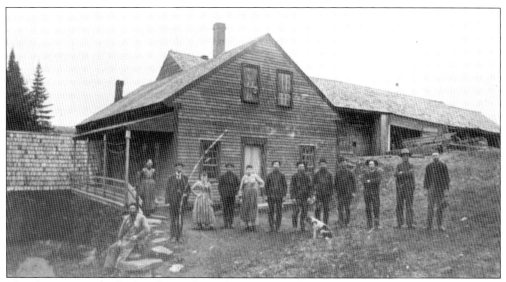

This house was built for the mill workers for Goslant Lumber. The photograph shows unidentified workers, both men and women, c. 1915.

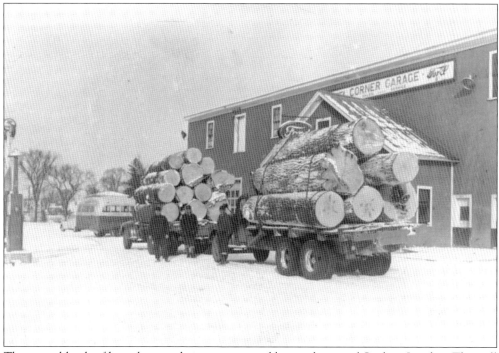

These truckloads of huge logs are being transported by employees of Goslant Lumber. The mill was originally built by Edward Sleeper and was later sold to Jesse Ordway. After that, it was sold to Mitchell Goslant and, in 1920, to E.T. Fairbanks. Fairbanks had a steam mill on Walden Mountain where lumber was cut for his scale business in St. Johnsbury.

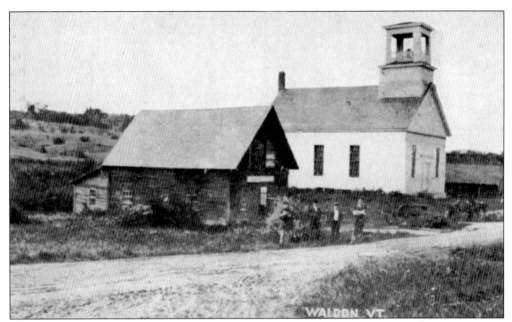

Fred Bancroft was the blacksmith from 1907 to 1916 in Walden next to the Walden Methodist church, shown c. 1930.

This c. 1900 photograph shows the store in Noyesville Village (in the town of Walden). This horse-drawn reaper was used for oats, barley, or wheat.

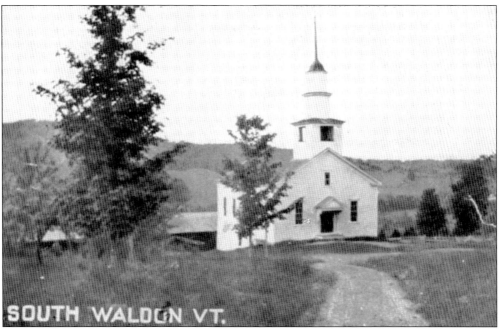

The South Walden Methodist Episcopal church was built in 1825 and was refurbished in 1897, when the two doors were made into one central door and new pews were added. The South Walden Ladies Aid raised money to support the church through suppers, ice cream socials, and through the sale of aprons and ties. These special times provided relaxation and time to visit with friends and neighbors. The society also provided for those who were sick or needy. Meetings were held at members' houses or the church vestry. Also on the agenda were times for prayer and work sessions of sewing and quilt making.

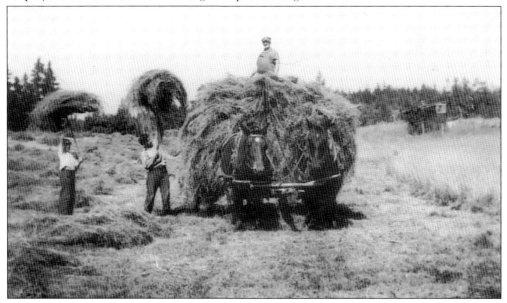

This is haying the old-fashioned way. Standing on top of the wagon is Israel J. Farrow. Pitching the hay are Alfred Lanphear and Edwin Rudolph, who was here from New York City to work in the summer of 1942. Brownie and Prince are the hardworking horses.

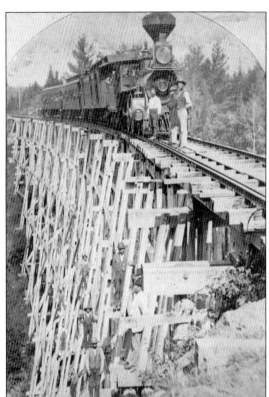

This trestle on the Portland and Ogdensburg Railroad is 100 feet high. Try to count the men standing from the top to the bottom of the trestle.

Edward Goodenough, shown with his fishing boat in 1904, is headed for Cole's Pond.

Danville

On October 26, 1786, Revolutionary War hero Gen. Jacob Bayley of Newbury, Vermont, and Jesse Leavenworth of Cabot petitioned the legislature for a grant of land in the area that was to become Danville. At the time it was chartered, it was a booming frontier shire town unlike the suburban community of today. For nearly two decades before the town was settled, it was the legal domain of the Royal Province of New York granted under the name of Hillsborough.

In 1910, farmers organized the North Danville Cooperative Creamery. They built the creamery in 1911 on land purchased from Frank and Mattie Hubbard for $17.50. Local residents found employment preparing butter boxes and wrapping butter in wax paper. Around 1945, Danville Creamery changed hands and became Vermont Cooperative Creamery. When they churned their last butter in 1948, they held the record as the longest continuously operated creamery in the state. Today the building exists as a popular restaurant owned and operated by the Beattie family. (Danville photographs courtesy of Margaret Springer, the Danville Historical Society.)

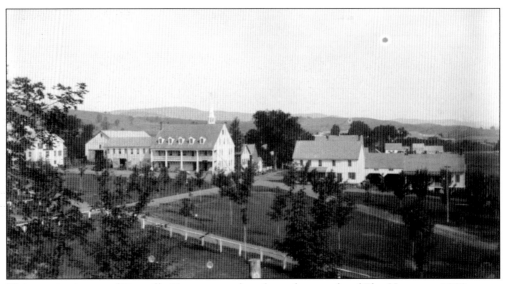

This scenic picture of Danville Green was taken from the cupola of Elm House, c. 1880.

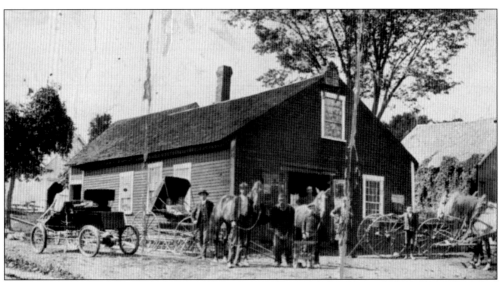

Shown is the Badger Blacksmith Shop in 1908. It was located just below the high school. The first car in town is visible; it belonged to Guy Pettingill and his brother, Ned.

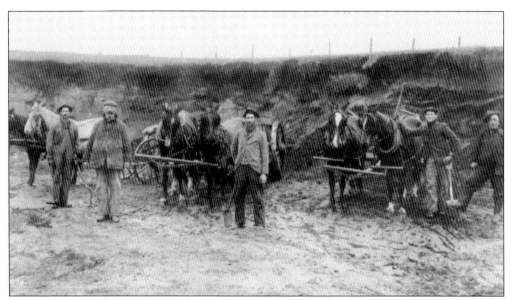

Removing gravel from the Danville gravel pit are Fred H. McCosco, Noel Burdick, Henry Weeks, (?) Bert Heath, and (?) Bert Hartshorn. The pit was on the site of Joe Peck's on Duck Pond.

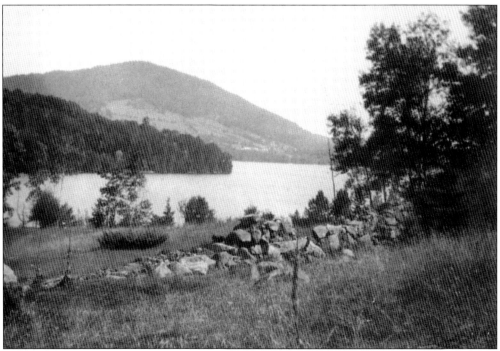

Indian Joe, for whom Joe's Pond is named, hated the British. During the French and Indian War, he gave information on impending Native American raids to settlers in Vermont. He was banished from the St. Francis tribe to an island in Danville. Molly's Pond in Cabot is named for his wife. They both died as paupers, but Vermont made provision for their support while they were alive. An inscription on his tombstone in Newbury reads, "Erected in memory of Old Joe the friendly Indian Guide who died February 19, 1819."

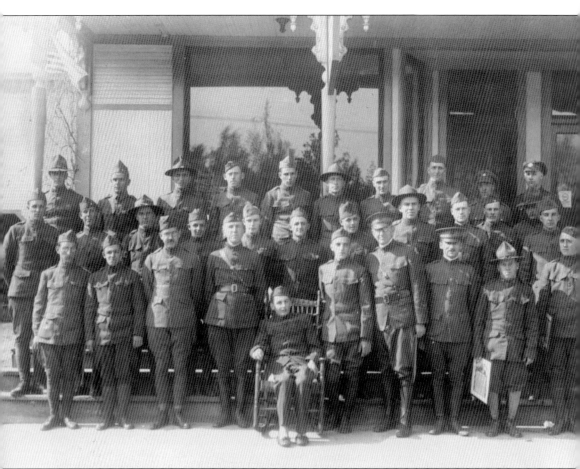

World War I veterans pose at their homecoming celebration in August 1919. There was a picnic dinner and a sugar party in the park. The town gave a certificate to everyone. Harry Osgood buried snow near Joe's Pond for cool drinks at the party, and the syrup was boiled in the park. This picture was taken in front of the Dole Block. Shown, from left to right, are the following: (front row) Joe Leslie, Ralph Emmons, Charles Brown, Chauncy Adams, Gene (Eugene) Gochie, Earle H. Fisher, Dr. Charles Libbey, Eleazer J. Dole, Curt Rollins, and Glenn Crane; (middle row) Albert Danforth, Morris Bigelow, Jack Johnson, Timothy Emmons, Earl Rodger, Edward Emmons, Percy Gould, Austin Smith, George Morse, Vern Devenger, Earl Coveny, and ? Way; (back row) unidentified, Leslie Morrill, Gus Roy, Clyde Green, Dan Coolbeth, Lester Smith, Ben Clifford, Raymond Osgood, ? Fox, and Raymond Dear (Canadian Army). Howard Cobb of the U.S. Navy is not in the picture.

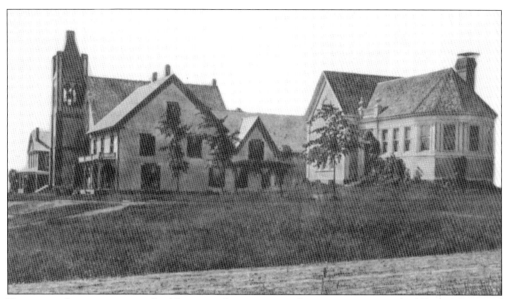

Featuring three prominent buildings in their town is this picture postcard of Pope Memorial Library, Caledonia National Bank, and the Methodist church on Danville Green.

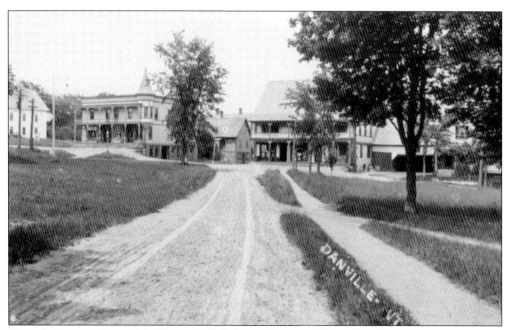

One of the many beautiful villages in Caledonia County is Danville Village.

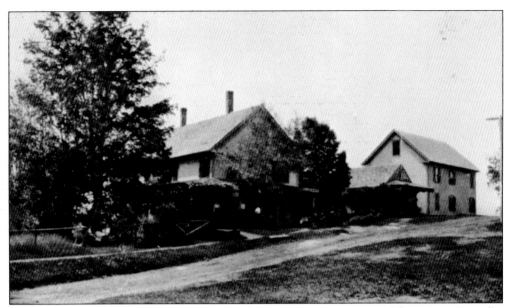

J.W. Gillis, Smith & Morse, and V.A. Dole owned these businesses in turn-of-the-century Danville.

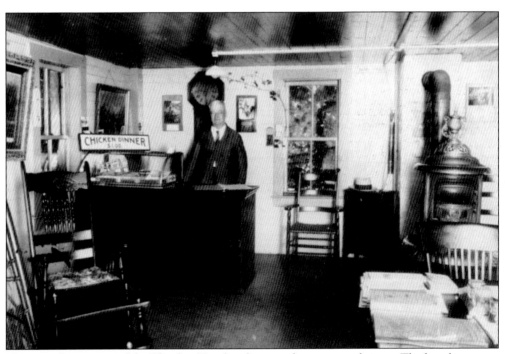

Shown is the interior of the Thurber Hotel and its simple accommodations. The hotel was torn down in November 1965.

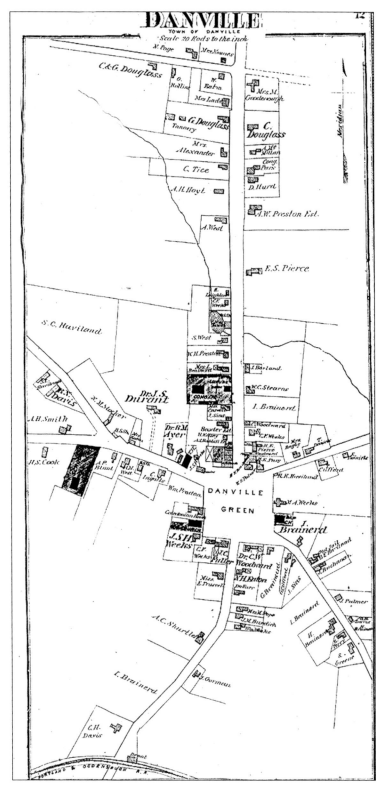

Danville is shown here.

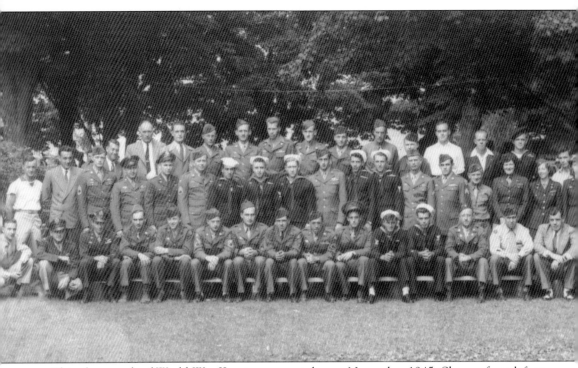

This photograph of World War II veterans was taken c. November 1945. Shown, from left to right, are the following: (front row) Martin Paulsen, Rolfe Chickering, Paul Sevigny, Martin Rodger, Harvey Dole, Arthur Woods Jr., James Pettingill, Luther Fellows, Paul Leighton, Philip Badger Jr., Gordon Ladd, John Hough, Joel Moore, unidentified, and Harold Miller; (middle row) Arnold Langmaid, Leland Swasey, Vale Swasey, Reginald Sevigny, Frank Kelley, Ralph Hastings, Rodney Morse, Paul Swett, Carroll Church, Donald Sargent, Roland Emmons, Wesley Ward, Alden Webster, Theodore Hutchinson, possibly Buster Joyce or Richard Brown, Katherine Chickering, Lillian Dole, and Lorraine Swasey; (back row) Leland Osgood, Ervin Chamberlain, Norman Sleeper, Roy Calkins, Leslie Smith, Gordon Morse, Walteer Osgood, Edward Carr, Austin Moore, Frank Boutwell, Richard Ide, Melvin Henderson, Ernest Henderson, and Henry Balivet. Not present are Reginald E. Smith and Neal Sargeant Jr., who was headed for Japan.)

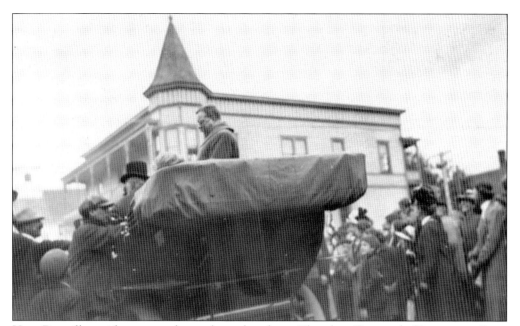

How Danville residents must have cheered to have Theodore Roosevelt (Progressive Party delegate) visit their town. Taft was the Republican candidate.

Shown is an unidentified procession down Main Street in Danville. Dr. Ayers's residence is in the background.

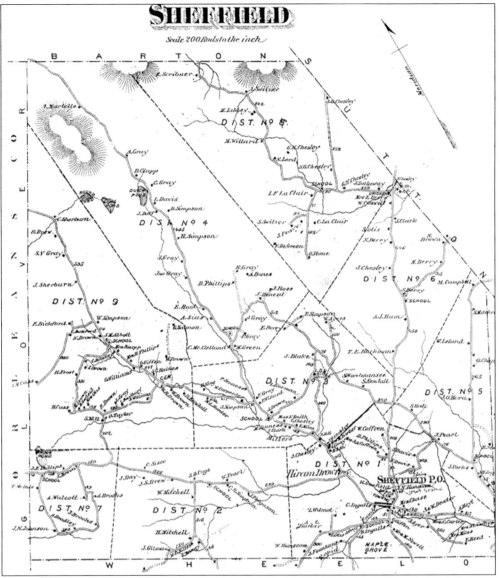

This is a map of Sheffield.

Two

SHEFFIELD AND WHEELOCK

Sheffield

Among the early settlers to Sheffield were Caleb Heath, Isaac Jenness, Samuel Daniels, Reuben Miles, Henry Gray, James Hodgen, and Samuel Weeks. Sheffield elected Stephen Drown as its first representative in 1806. Archelaus Miles Jr. was the first town clerk as well as one of the first selectmen with Stephen Drown and Isaac Keniston. The first constable was Jonathan Gray. William Gray and Hannah Jenness were the first children born in town, in 1794. The first schoolhouse (1805) was erected on land later owned by Sylvester Hall. A veteran of the War of 1812, Capt. Joseph Staples, was the first blacksmith. (Sheffield photographs courtesy of the Sheffield Historical Society.)

The first town hall in Sheffield was built in 1900 and burned in March 1942. For decades this meetinghouse was the architectural centerpiece for the village. The fire was believed to have been caused by the wood furnace in the basement, which had been stoked to warm the building for a town meeting; it was a total loss and was not replaced until some 13 years later.

Early Sheffield resident Sarah Jenness Twombly was born on October 5, 1798. She was the daughter of Richard and Martha Jenness and married Daniel Twombly, the son of Capt. Samuel and Elizabeth (Gray) Twombly.

Cutting wood with horsepower in 1929 are Roland Simpson and Oney Simpson.

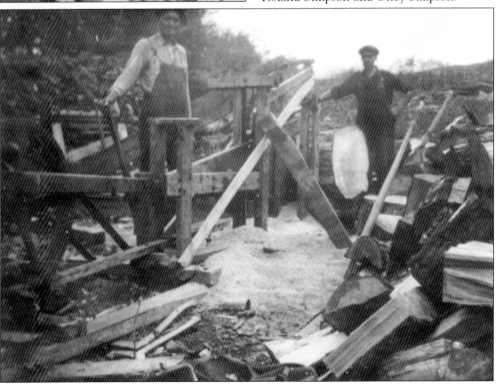

These photogenic people are Matie and Harley Keniston. Because of their strong belief in education, their estate has been left in perpetual care for the benefit of Sheffield and Wheelock students for their college education. Their children, Harry and Marion, also carried on this generous tradition.

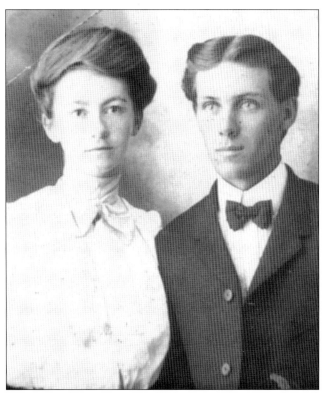

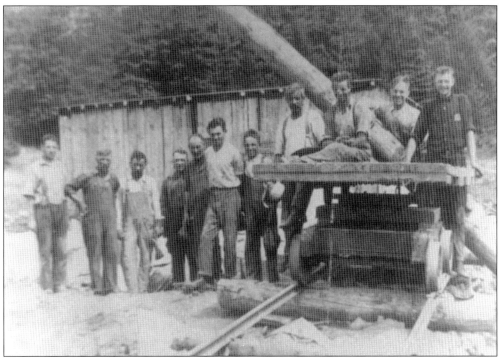

Among the Sheffield Black Granite crew are Bernie Blair, Adai Brown, Leon Stone, Fred Stone, and Clifton Stone, photographed c. 1921–1930.

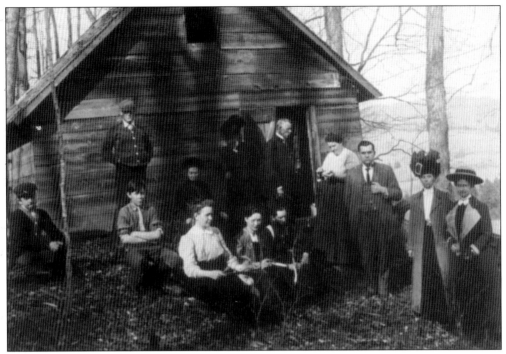

These people at an early sugar party in Sheffield are enjoying fresh sugar on snow.

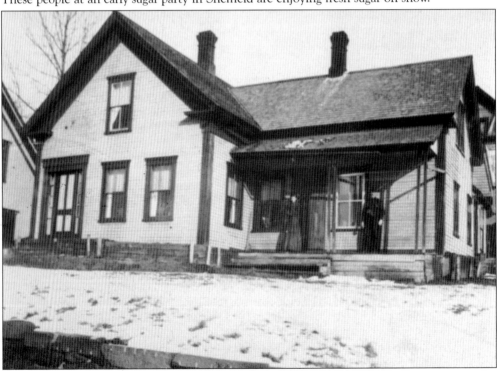

The Fayette Barber house, shown here, was built in 1870. John and Belle Orcutt are on the porch. Notice the early street lamp on the right. The building is now owned and occupied by Ed and Pat O'Hagan.

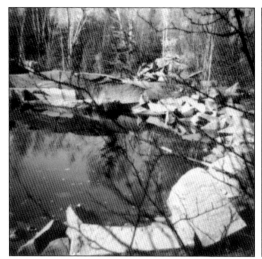
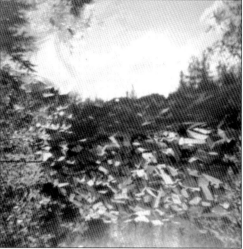

These photographs show the Sheffield Granite Quarry as it appeared in 1966. Today, the site is being mined extensively once again. It will never look quite the same. (Photographs courtesy of Harriet Fisher.)

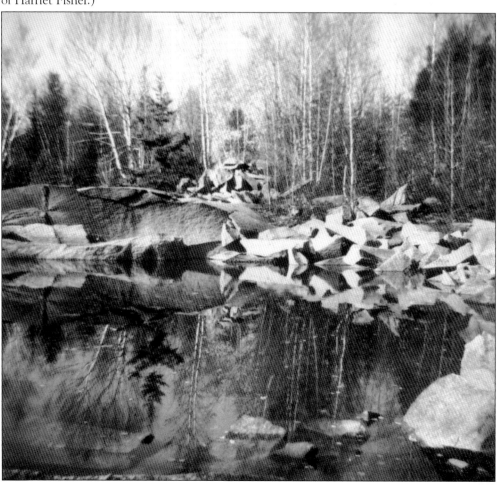

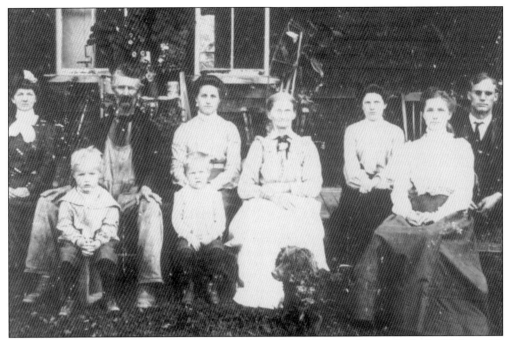

This rare photograph of a Civil War veteran shows John Blake and his wife, Lydia Blake, with three of their grown children. Sarah (Blake) Gray is to right of John. Zenas is at the extreme right, and Martha (Blake) Petrie is at the right front.

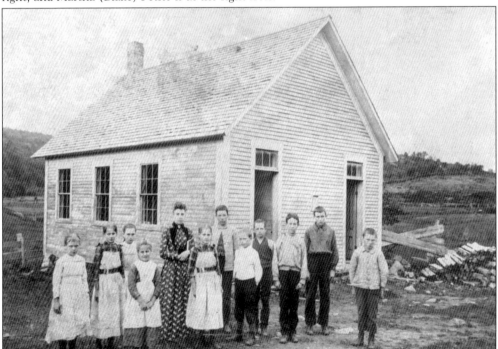

This schoolhouse was located on Sheffield Square. There were originally several school buildings in town, as it was divided into different districts. Today, the educational needs of both Sheffield and Wheelock children are being met by the Miller's Run School (Unified District 37).

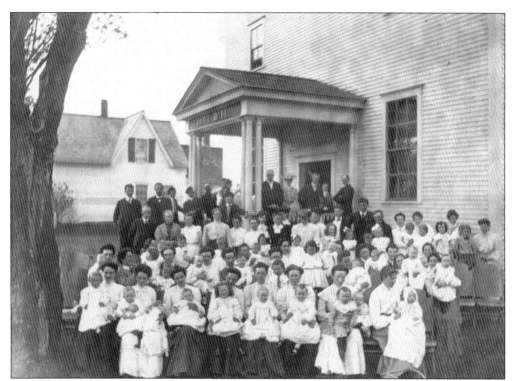

This town photograph was taken in 1906. The babies on the left are Marion and Harry Keniston. This was the original town hall, built in 1900. Another town photograph was taken in June 2000 in front of the second town hall, built in 1954.

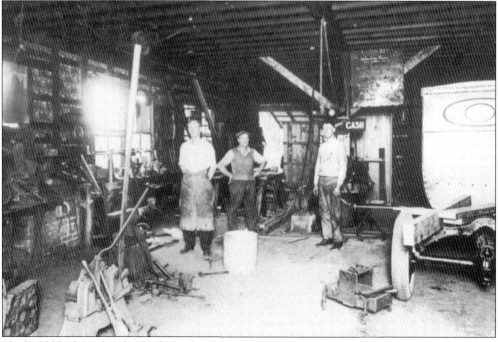

Sheffield blacksmith John Barber is hard at work.

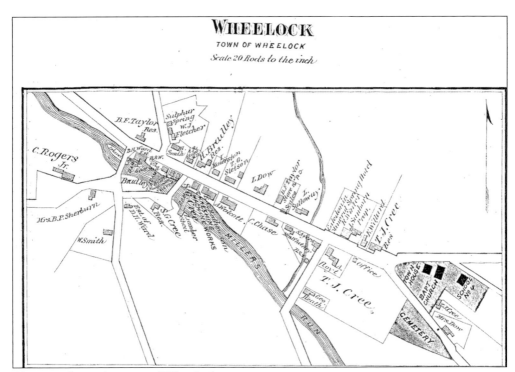

This map shows the town of Wheelock.

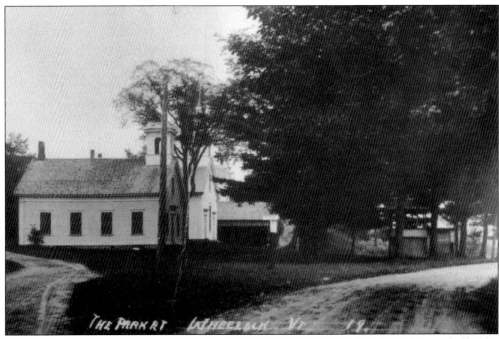

Shown as it used to be is the park in Wheelock in front of the church and town hall. The church building has been razed.

40

Wheelock

In 1790, Samuel Weeks began settling Wheelock Hollow. He was followed by Col. John Chase, Erastus Fairbanks, and Ward Bradley. The brick hotel (no longer located in Wheelock) was built by Samuel Ayers *c.* 1830 with a tannery opposite. About 1832, the meetinghouse was built. Abraham Morrill was the first town clerk, and Gideon Leavitt was the first constable. Wheelock is most noted as being the whole township that the state set aside toward support of Dartmouth College, which is located in Hanover, New Hampshire. Today, it remains an unspoiled tranquil town with the town hall and village store being the center of community events and social visits. (Wheelock photographs courtesy of Duane Smith and Anita Zentz except where noted.)

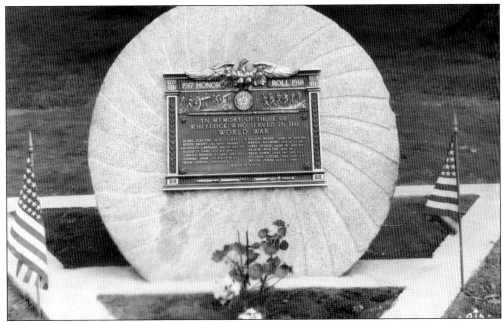

This World War memorial is located on the green in front of the present town hall in Wheelock village on route 122.

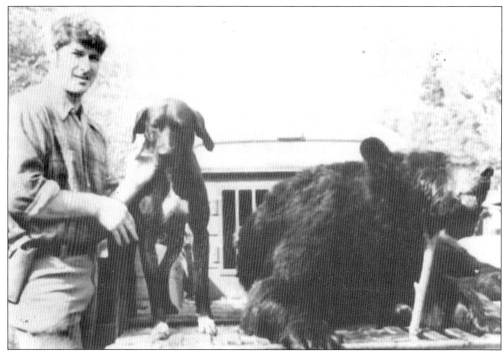

Gaylon Smith is quite a hunter! He shot this bear and set a New England record—585 pounds, live weight.

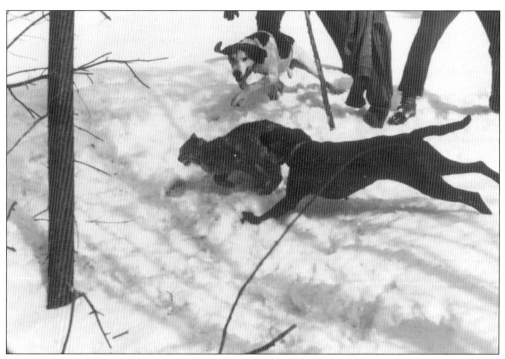

These Wheelock hunters have finally caught up with that wildcat. It pays to have good hunting dogs leading the way.

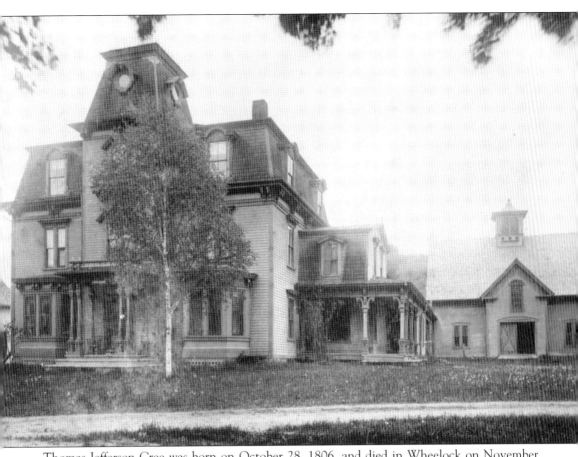

Thomas Jefferson Cree was born on October 28, 1806, and died in Wheelock on November 9, 1880. On January 1, 1834, he married Ann Stone. On the same day, he took his bride from Cabot to Wheelock, where he built a home, as he was a carpenter and joiner by trade. He was moderator from 1858 to 1869 and again from 1872 to 1877. He was lister in 1858, 1865, and 1874 and town treasurer from 1859 to 1866. He served as town agent from 1859 to 1863 and from 1865 to 1872. He represented the town in 1848 and 1849, was assistant judge from 1848 to 1851, a member of the Constitutional Convention in 1857, and a Caledonia County senator from 1862 to 1863.

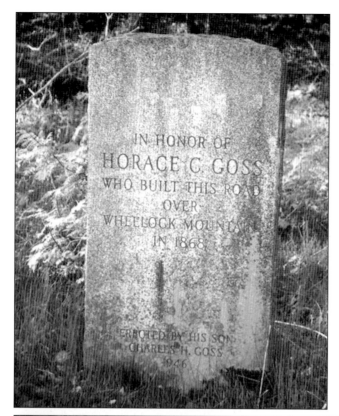

This monument was erected in honor of Horace C. Goss, who built the road over Wheelock Mountain to Stannard in 1868. (Photograph courtesy of the author.)

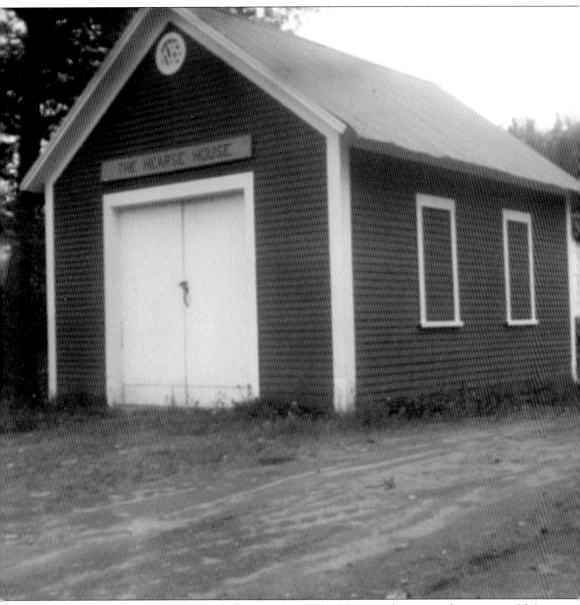

According to *The History of Wheelock*, printed in 1961, "As in earlier years, the vote was 'No' when first a new road was proposed. The mountain road was designed to connect Wheelock and Stannard, the new name given to Goshen Gore, as an honor to General Stannard, Civil War hero. By 1869, the road was completed by Horace C. Goss. It is now the main road west out of Wheelock."

Early in the 1940s, the Hearse House was moved from the lower end of the old village cemetery to sit beside the schoolhouse. It was then moved from its original location—the corner of John Rock and Peak Roads. The schoolhouse was to be used as the grader shed. The Hearse House was meant for storage. The hearse that the town had stopped maintaining years before was sold for $25.00. The women in Wheelock opposed moving the Hearse House. They wanted it attached to the town hall and converted into a kitchen.

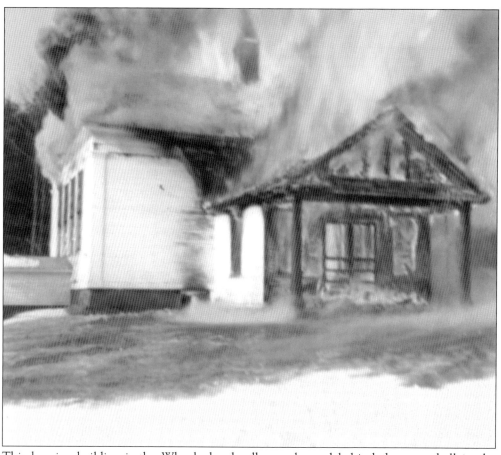

This burning building is the Wheelock schoolhouse, located behind the town hall in the village. (Courtesy of Rebecca Martin.)

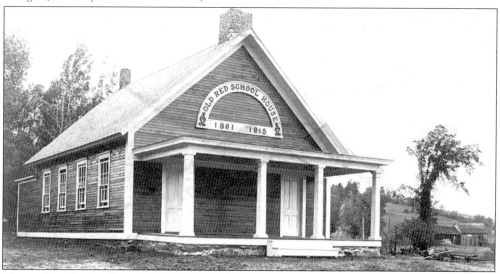

This early red schoolhouse in West Wheelock still stands today, although it is not used as a school. It has been very well maintained.

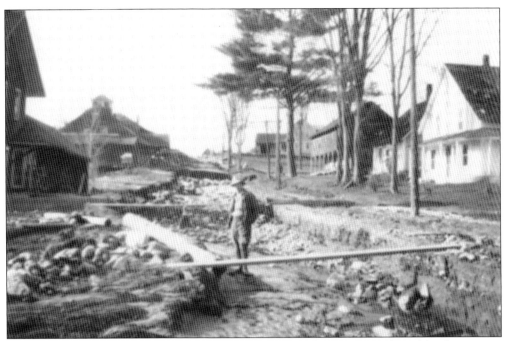

These two scenes looking north and south in Wheelock Village are reminders of the devastation that occurred as a result of the flood of 1927.

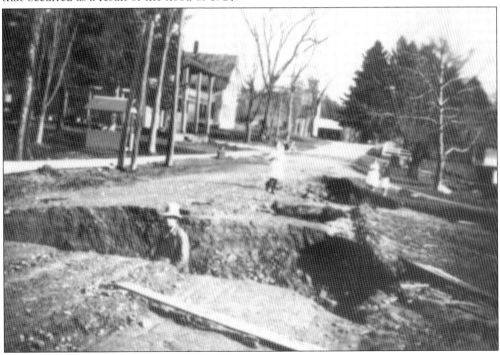

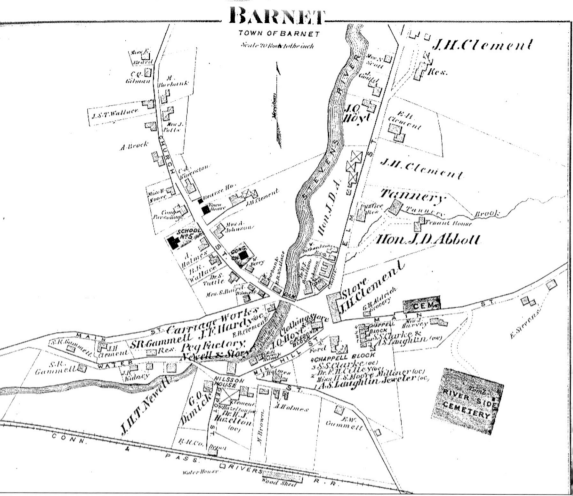

The town of Barnet is featured on this map.

Three

BARNET AND RYEGATE

Barnet

"The Barnet and Ryegate areas were settled by people from Scotland just before the outbreak of the Revolutionary War. This area has the distinction of being considered as one community and remains the only one in Vermont settled by a body of people from beyond the Atlantic." (Taken from *Barnet History 1760–1923*.) Simon Stevens, William Zenas Stevens, and Elijah King were the actual early settlers.

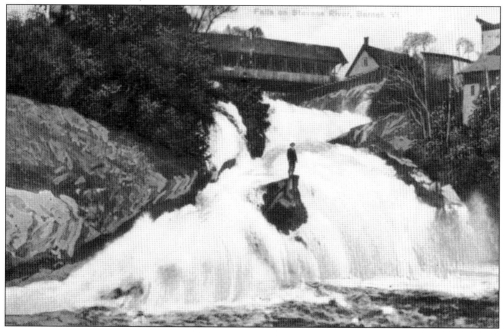

This view shows the falls on Stevens River in Barnet. The man standing in the middle of the falls is unidentified, and how he got there is a mystery. (All Barnet photographs courtesy of Duncan and Jean McLaren, the Barnet Historical Society.)

The note on the back of this picture reads, "You recall these old woodburners on B & M Railroad back in the 1890s. This one was built in 1858 in Roxbury for Boston and Providence Railroad and was at Chicago in 1893. It is still in good repair."

This old blacksmith shop is quite a structure on Stevens Falls in Barnet.

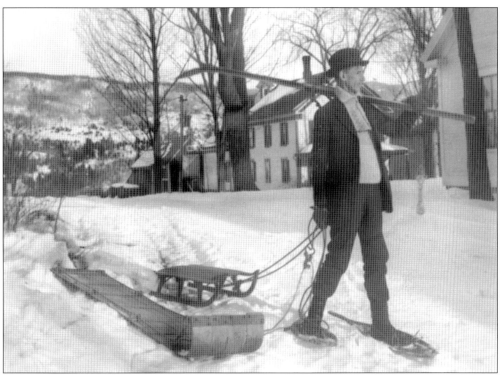

Reverend Bliss took many of the pictures for the Barnet history. In this photograph, he is either interested in all winter sports or he cannot decide which one to do today.

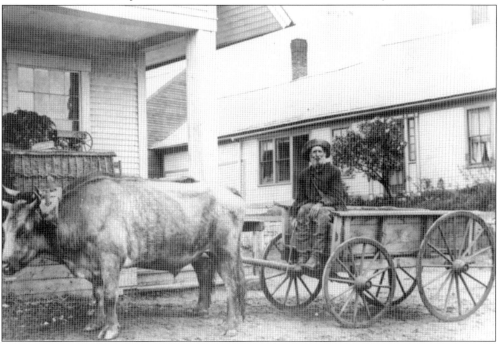

Not much is known about this man, except that the picture states that his name is Dirty Mose Hunter from West Barnet.

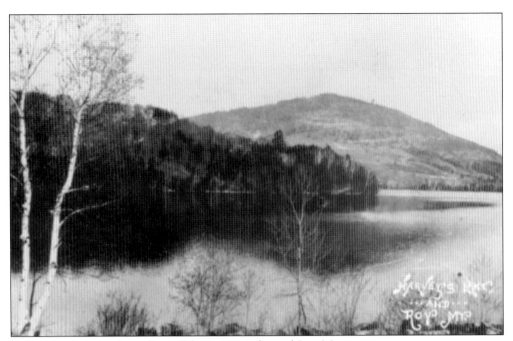

This tranquil scene shows beautiful Harvey's Lake and Roy Mountain.

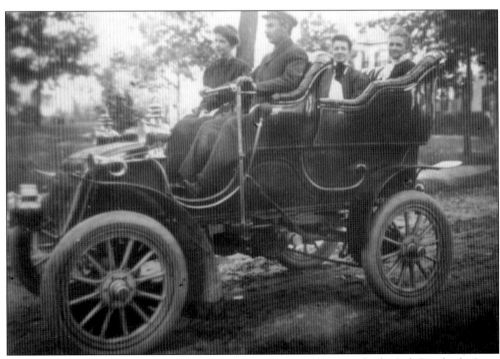

Going for a ride in the first automobile in McIndoes are Zet Goodrich, Jed Goodrich, Lucy Buffan, and Nellie Manchester.

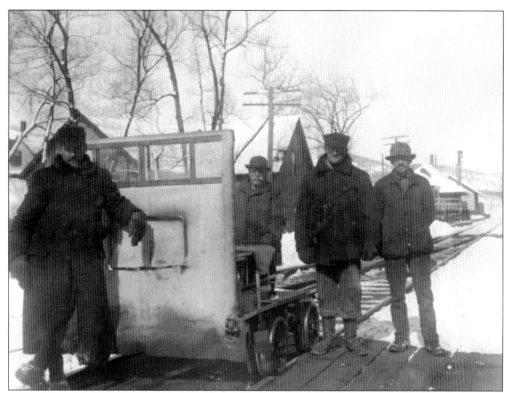

This view of McIndoes looks north. This section men's car was for working on the track. The old car was propelled by the men pumping the handles.

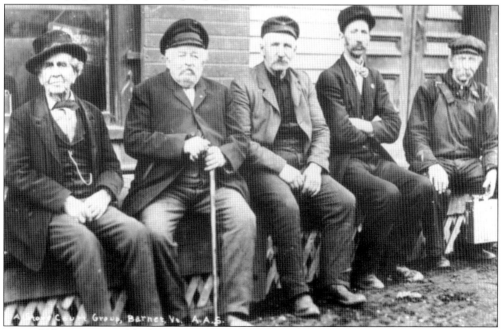

Jim Gilfillan, Sam Stoddard, Harvey Judkins, Moses Bruso, and Jim Lang are perhaps talking politics and the business of the day.

This article from an unidentified publication relates the story of a fire at the Roy Brothers Croquet Factory.

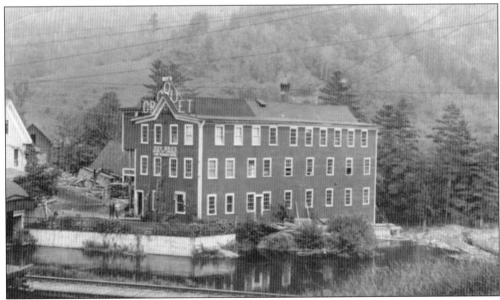

This photograph's original caption reads, "Founded in 1888, the Roy Brothers Croquet Factory is owned by J.G. Roy, son of one of the original proprietors. The firm cuts its own wood in the surrounding hills, peels and treats the timbers, and produces in huge numbers the mallets and balls used in the still popular lawn pastime. Paint and varnish are the only materials used that are not produced locally. Hard maple, second growth ash, and birch are the woods used." (*Milwaukee Journal.*)

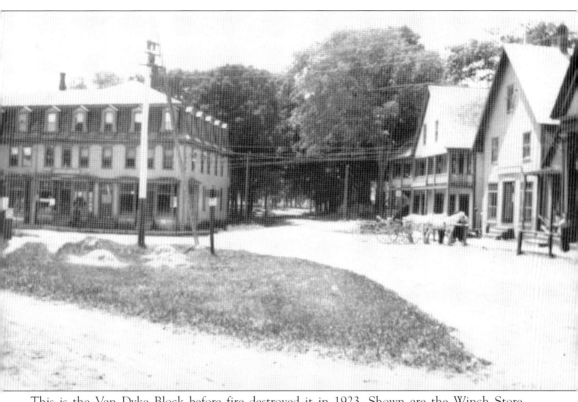

This is the Van Dyke Block before fire destroyed it in 1923. Shown are the Winch Store, Guthrie's Drug Store, and Perry's Store.

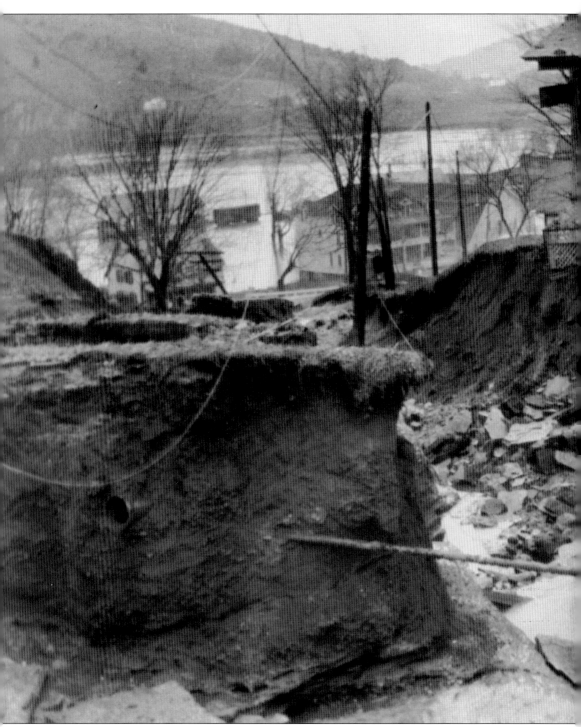

This fantastic view shows Rowes Store and the Barnet Post Office (in 1980, Kimballs' and Miles) after the November 1927 flood. It shows the Barnet railroad station and a freight car surrounded by water. The hotel (in 1980 Dunbar's Apartments), built after the old hotel burned in 1912, was above the high water mark. Old cars and anything to fill the washout down Mill

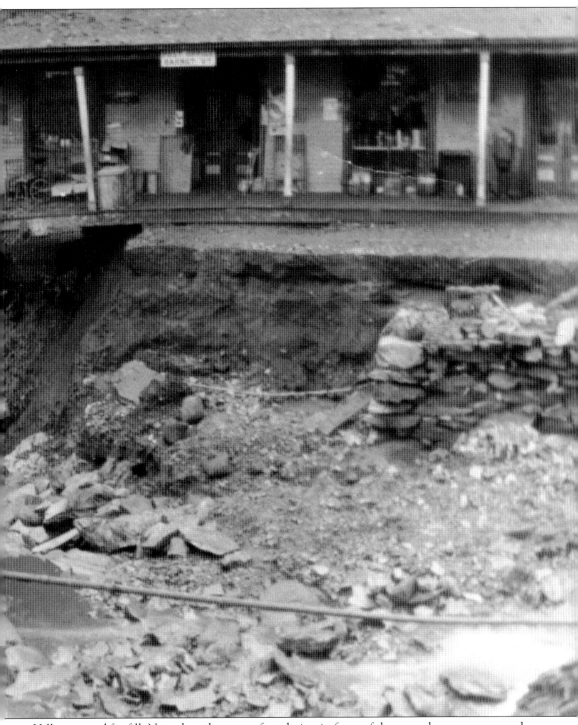

Hill were used for fill. Note the other stone foundation in front of the store that was uncovered. Speculation was that this building was probably a part of the old wooling mill that burned on December 15, 1869. This was a six-story building, 65 by 44 feet, with two wings 60 and 70 feet long. The mill was chartered in 1825. There was also an office and two-story storage building.

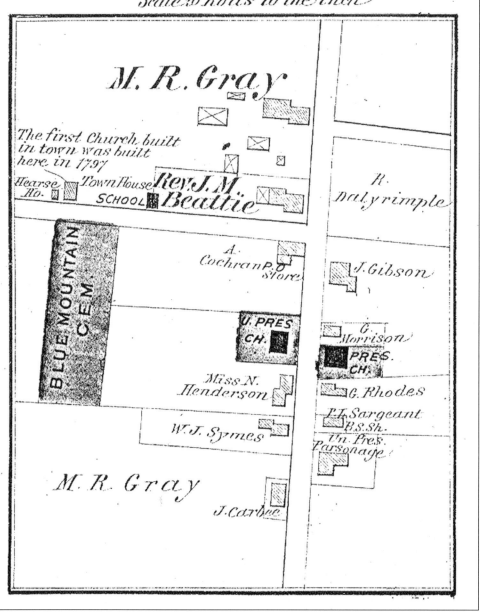

This map shows Ryegate.

Ryegate

Patrick Reid was a merchant and landowner who settled in Ryegate. An old map in the state library shows Ryegate "as beginning at the mouth of Wells River and extending to the mouth of the Passumpsic, Barnet covering part of what is now Waterford." Barnet is called "a large tract of excellent land." Because of the close proximity of Barnet, Ryegate, and McIndoes, it would seem that people were not always sure of where they did live, as witness to the preamble to a deed on record. "Know all men by these presents that I, Amos Kimball, of a place called Barnet within a district of country known by the name of the New Hampshire Grants on the westerly side of the Connecticut River, alias, in the County of Gloucester and State of New York" Nevertheless, Ryegate was chartered on September 8, 1763, and Barnet eight days later.

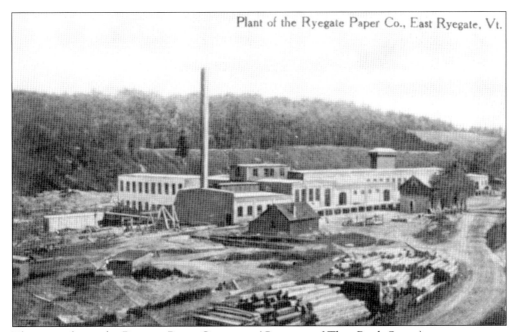

Plant of the Ryegate Paper Co., East Ryegate, Vt.

This view shows the Ryegate Paper Company. (Courtesy of That Book Store.)

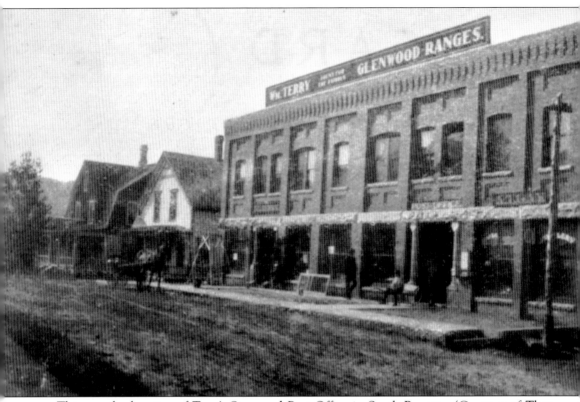

This was the location of Terry's Store and Post Office in South Ryegate. (Courtesy of That Book Store.)

This is the Presbyterian church in South Ryegate, Vermont.

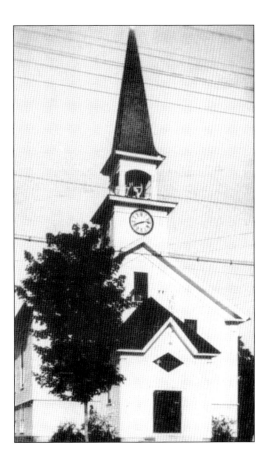

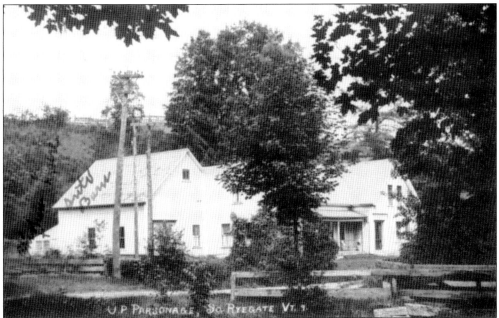

This building was once the parsonage in South Ryegate.

Main Street in South Ryegate is shown as it appeared long ago.

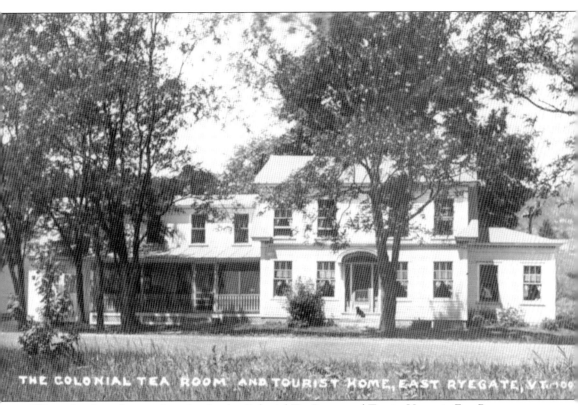

THE COLONIAL TEA ROOM AND TOURIST HOME, EAST RYEGATE, VT. 100

What a lovely and tranquil setting for the Colonial Tea Room and Tourist Home in East Ryegate.

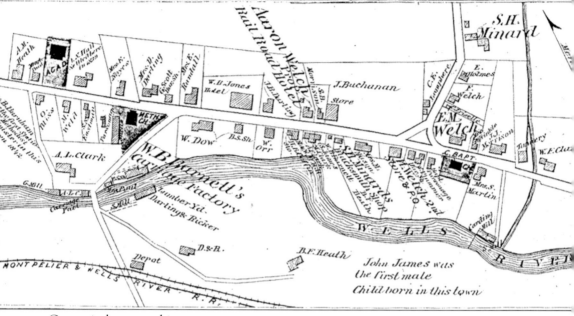

GROTON
TOWN OF GROTON
Scale 20 Rods to the inch

Groton is shown on this map.

Four

GROTON

The first settlers in the northern part of town were Edmund Morse, James Abbott, and Mr. James. The sawmill built by Captain Morse was succeeded by one that was later operated by Amazia H. Ricker. The first child born in Groton was Sally Morse. One of the youngest arrivals in town was John Taisy who, born in Scotland in 1791, came to Groton in 1795. His first wife was Phebe Heath.

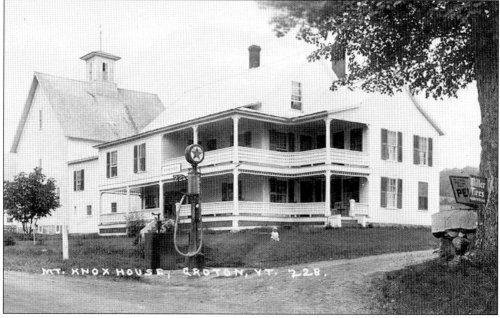

This picture shows the Mt. Knox House, located in Groton village. Notice the early gas pump. (Groton photographs courtesy of Dean Page, the Groton Historical Society.)

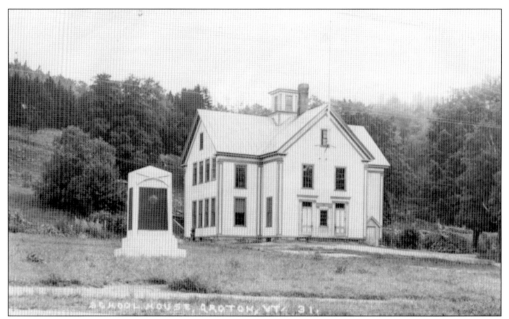

Shown is a good-sized schoolhouse in Groton with a Civil War monument on the front lawn.

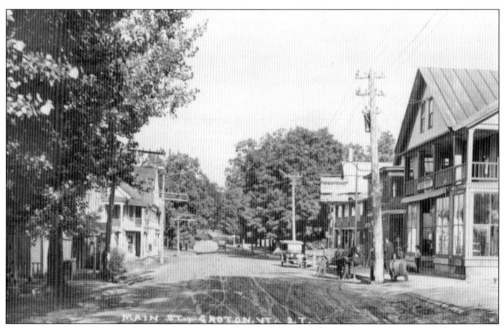

The wide unpaved roads in this early view of Main Street in Groton were typical of that time.

Shown is the rather high steeple of the Methodist Episcopal church in Groton.

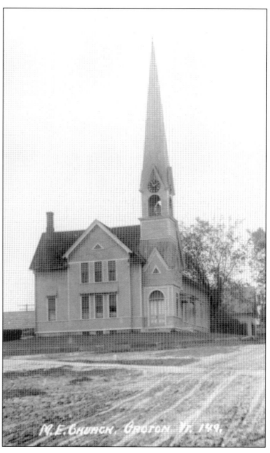

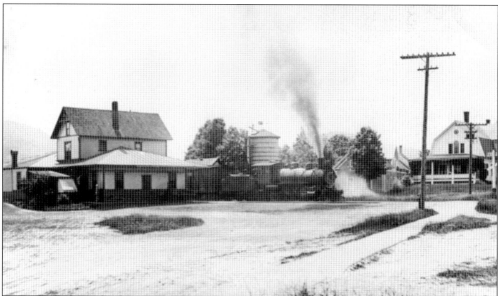

A blast from this railroad engine shatters the calm of Groton as it passes through the quiet countryside.

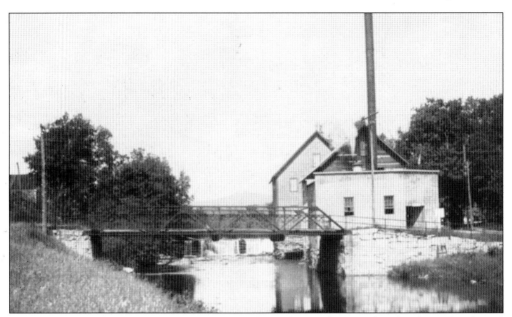

The Turning Works in Groton turned out small wooden products such as knobs for kettle and pipe stems. The building burned in 1926 and was not rebuilt.

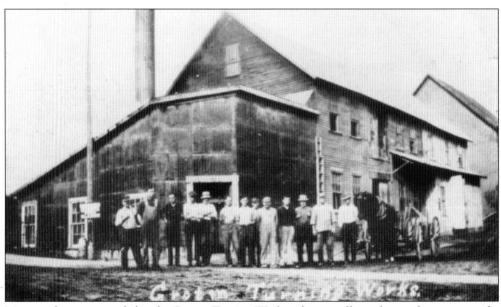

Many workers were needed at the Groton Turning Works, where small wooden products were made.

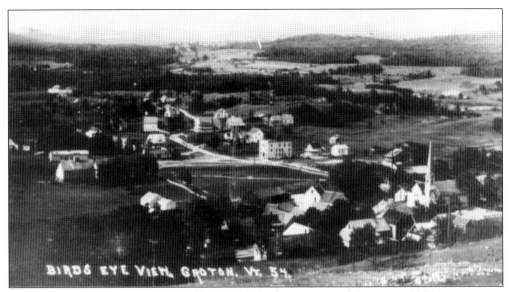

Showing yet another picturesque village is this bird's-eye view of Groton in 1954.

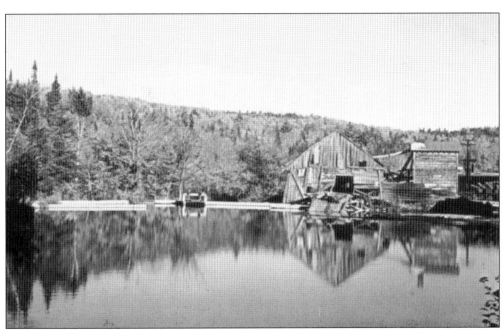

Built in 1790, Ricker's Mill is one of the oldest continually operating sawmills in the United States. Lumber is sawed for Vermont Treefarms Inc., makers of Turnbridge tables. The factory and store are located on U.S. Route 302 in Groton Village.

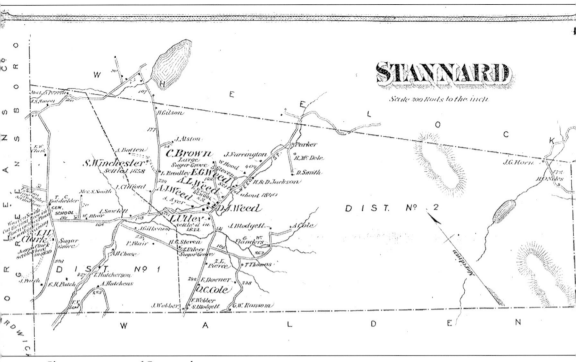

Shown is a map of Stannard.

Five

STANNARD

The smallest town in all of Caledonia County and crisscrossed by many roads is the town of Stannard. Until 1867, when it was chartered, Stannard was called Goshen Gore. The first person in Goshen Gore to build a house was Elihu Sabin, in 1802. There were, at one time, two churches, a town hall, and a sawmill in Stannard. The first schoolhouse was built in 1823 and the second in 1834. Other early settlers were Rubin Smith, Elisha Shepard, Rubin Crosby, Thomas Ransom, Asariah Boody (?), and Ephraim Perrin, who built his log house against the giant boulder and incorporated it as the back of his fireplace.

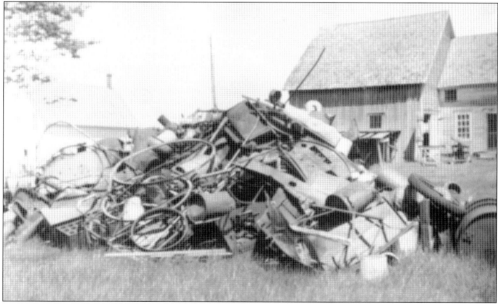

During World War II, it was customary to gather scrap metal to donate to the cause. This pile was collected by Stannard residents during the war. (Stannard photographs courtesy of Harold and Mavis Nunn.)

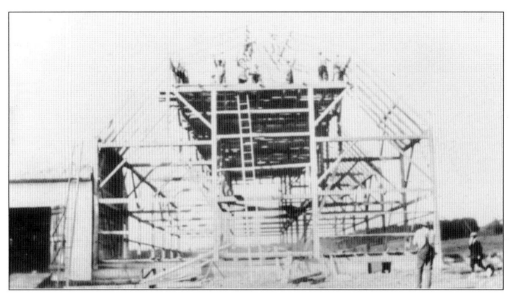

Neighbors helping neighbors was a common sight, as is illustrated by this barn-raising in 1918 at the farm of Charlie Winchester. The house was built in 1916. The house is currently occupied by Harold and Mavis Nunn.

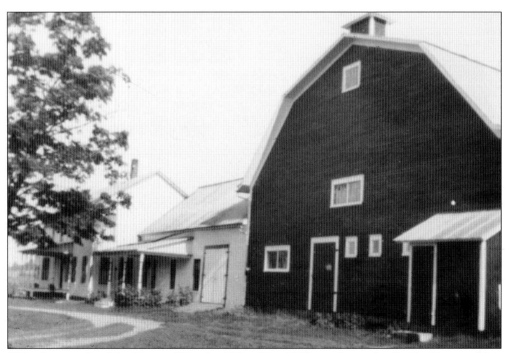

This photograph of the home of Mr. And Mrs. Harold Nunn shows the finished barn, which was under construction in its early stages in the previous photograph.

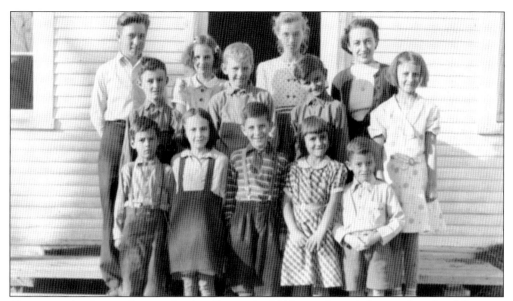

Shown at the Lower Stannard schoolhouse in 1940 are, from left to right, the following: (front row) Roger Gonyaw, Katherine Gonyaw, Roland Chouinard, Marcelina Degreenia, and Lionel Chouinard; (middle row) Randolph Gonyaw, Gordon Winchester, Forrest Degreenia, and Margaret Degreenia; (back row) Howard Brown, Mavis Winchester, Dorothy Sylce, and teacher Yvonne Bragg.

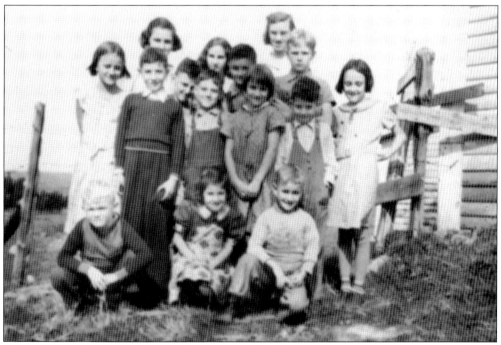

Shown are students from Stannard School in 1941. New students, in the front row, are Gordon Heath, Lorraine Chouinard, and Welcome Degreenia.

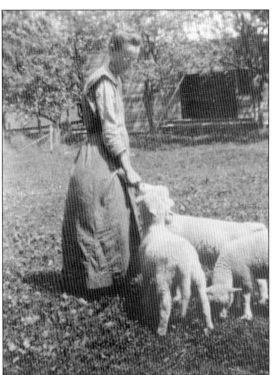

Effie (Cargill) Winchester, grandmother of Mavis Winchester, is shown feeding lambs in 1892. She was the oldest of four children and was born in Morgan, Vermont. In 1890, she married Charles Winchester.

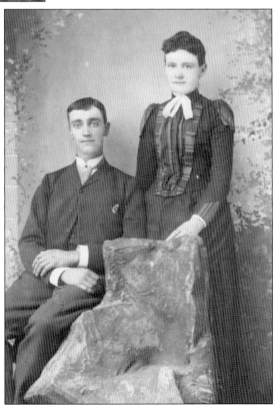

This wedding picture showing Charles Winchester and Effie Cargill Winchester was taken in 1890.

74

Shown is the Methodist church in Stannard.

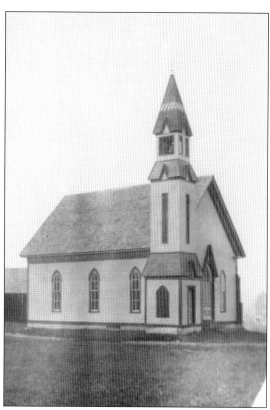

This washout occurred in 1940 as a result of localized flooding. The picture was taken from the Mountain Road.

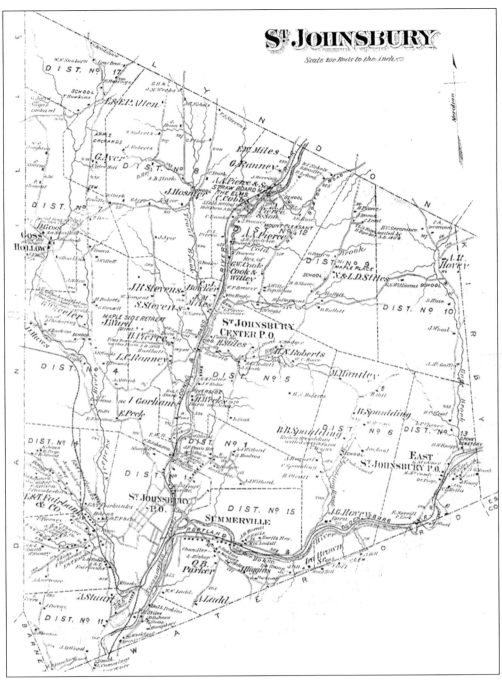

St. Johnsbury is shown here.

Six

ST. JOHNSBURY

On November 1, 1786, a grant was signed by Gov. Thomas Chittenden to Jonathan Arnold and associates for a tract of land in old Orange County. The chief proprietor and founder of St. Johnsbury was Dr. Jonathan Arnold, who had been a sergeant and surgeon in the revolutionary army and a member of the Continental Congress. It is believed that the town acquired its name from of Dr. Arnold's son, John, who because of his early death acquired the saintly prefix. Today, the town of St. Johnsbury remains the center of much commerce, industry, and booming development for all of Caledonia County.

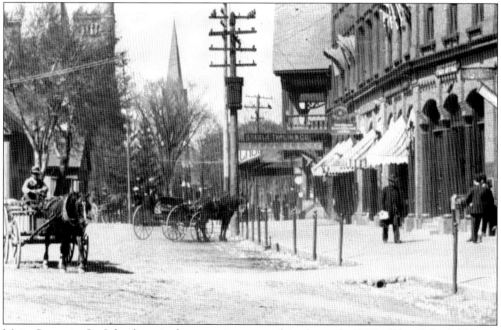

Main Street in St. Johnsbury is shown as it appeared in the early 1900s. The Colonial House on the left was moved to Green Street when the armory (now the recreation center) was built in 1915. (St. Johnsbury photographs courtesy of Graham Newell.)

Emma Fairbanks is having a rest on the veranda of her home, *c.* 1900.

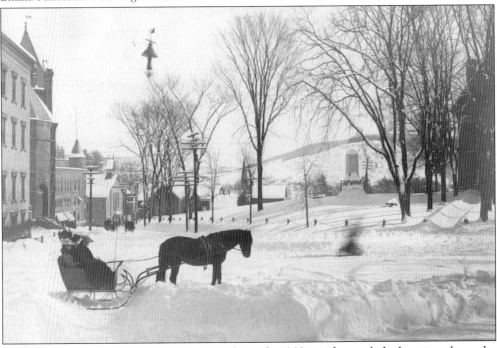

This is a lovely view of Eastern Avenue in the early 1900s, with a gaslight hanging above the street. The blur is a teacher at St. Johnsbury Academy, Miss Haskell, who is running in a vain attempt to escape being photographed. It would have been better for her to have stood still and to have been recognizable.

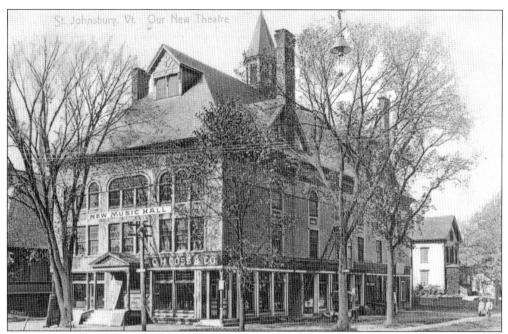

At the time that this was a new theater, Graham Newell recalls attending minstrel shows here. The building featured a wraparound balcony. Now it is the home of Colonial Apartments, located across from the North Church in St. Johnsbury.

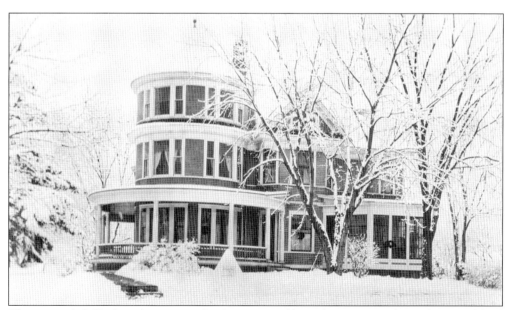

The original C.H. Goss house was the first to install an elevator. It is located on Highland Avenue and was owned by a wealthy man in the 1930s.

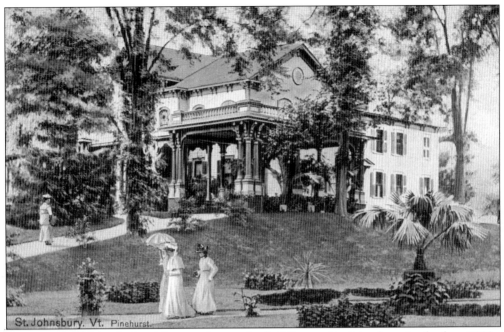

Gov. Horace Fairbanks lived here and gave the building to St. Johnsbury in the late 1800s. Maintaining its original lavish interior features, it is now home to the Elks.

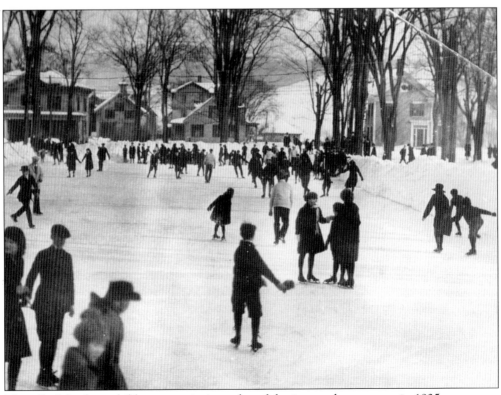

Many St. Johnsbury children are enjoying a day of skating on the common in 1925.

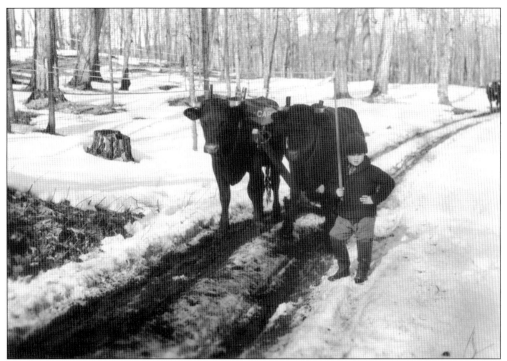

This unidentified young man is helping with the sugaring operation by driving the oxen for the Cary Sugar House in early spring. George C. Cary was the founder of Cary Maple Sugar Company and was dubbed "America's Maple Sugar King" in the 1920s.

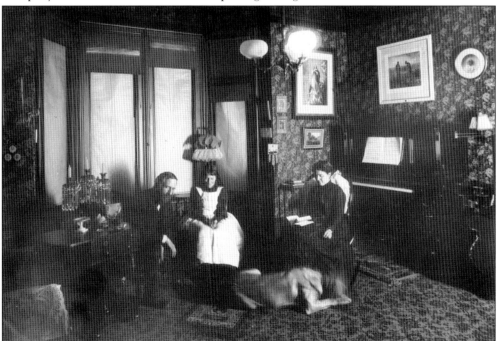

Displaying a wonderful Victorian parlor in 1890 are Edward Taylor Fairbanks with his wife, Emma, and their daughter, Cornelia. Their home was called Sheepcote.

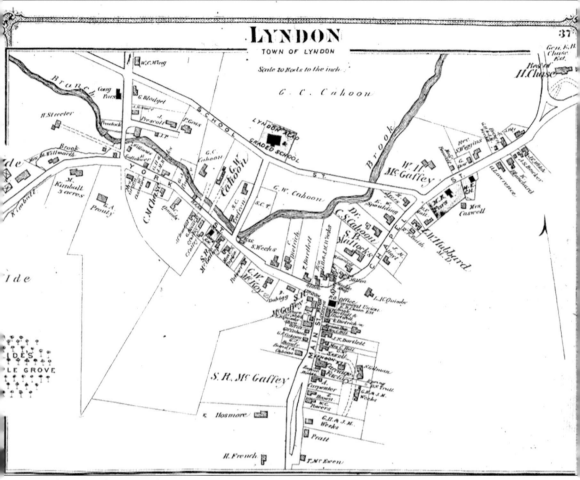

This map shows Lyndon.

82

Seven

LYNDON

The town was first organized on July 4, 1791, the year that Vermont became the 14th state in the union. Elder Philemon Hines was elected moderator and Daniel Cahoon Jr. served as clerk. Selectmen and listers were James Spooner, David Reniff, and ? Cahoon. Nehemiah Tucker was the treasurer, and Nathan Hines was constable and collector. At that time, Lyndon boasted a population of 59. Two years later, Daniel Cahoon Jr. died of consumption. That same year, his father came to Lyndon from Providence and, by 1796, had built the first flour mill and the first sawmill in town.

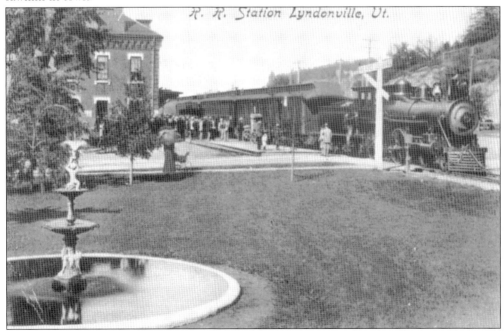

One of the many railroad stations in Caledonia County is the station shown here in Lyndonville. (Lyndonville photographs courtesy of Harriet Fisher except where noted.)

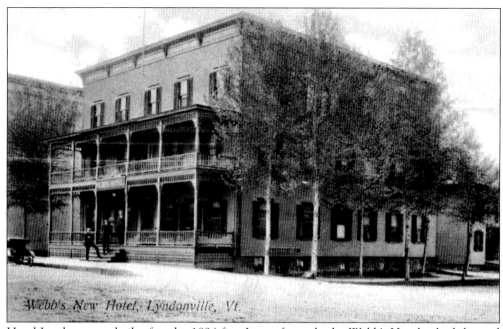

Hotel Lyndon was rebuilt after the 1894 fire. It was formerly the Webb's Hotel, which burned again in 1924.

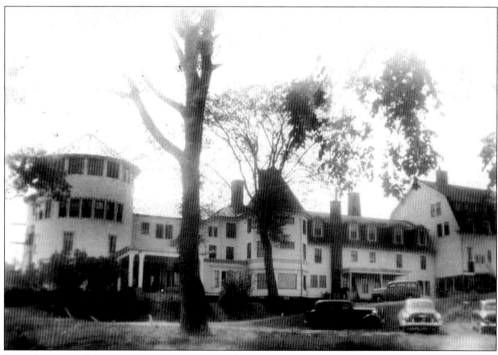

The elegant Vail Mansion as it appeared in the 1940s is a rare sight. There are not many grand structures such as this standing today.

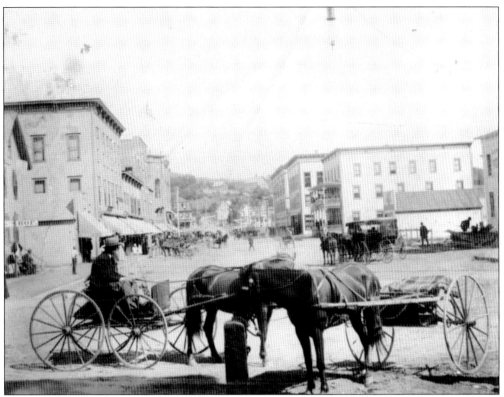

This was busy Main Street in Lyndonville at the turn of the century. Horses and many different styles of wagons were the transportation at that time.

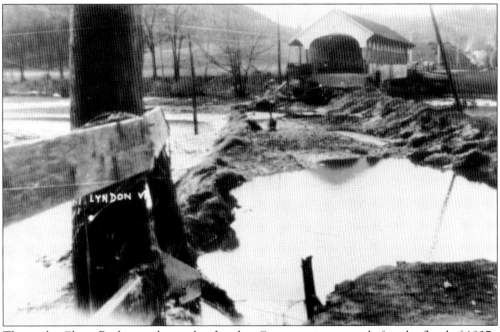

This is the Chase Bridge on the road to Lyndon Corner as it appeared after the flood of 1927.

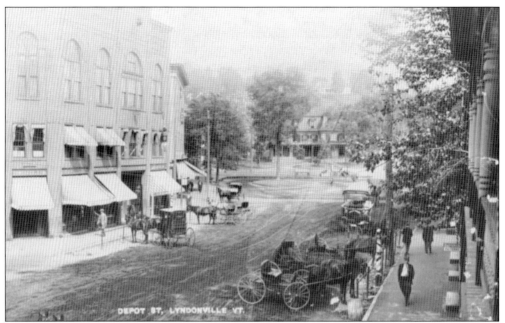

Imagine strolling down Depot Street as it once appeared in all its glory in Lyndonville.

One of the most important of the historical buildings in Lyndon Center is the Shores Memorial Museum, an outstanding Victorian building complete with original furniture and added collections to complement this great donation made by Dr. Venila Shores.

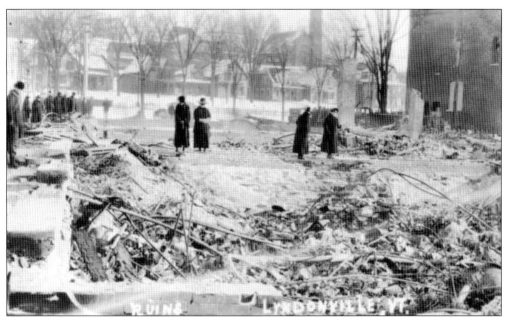

These photographs show some of the ruins after a fire in 1924 destroyed half of Depot Street in Lyndonville.

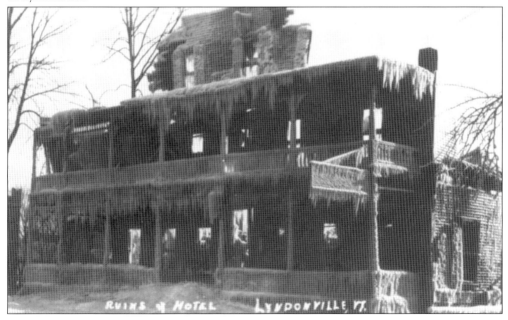

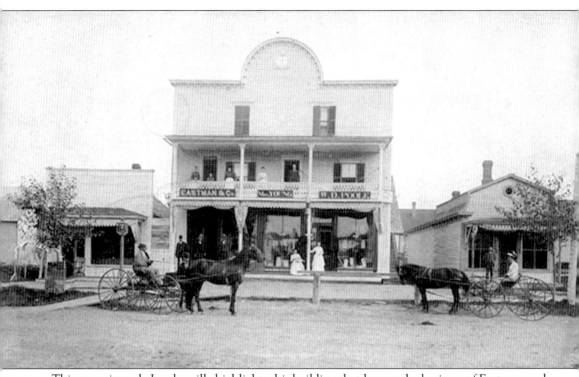

This scene in early Lyndonville highlights this building that houses the business of Eastman and Company, Mrs. Young, and W.D. Poole.

Eight

THE TOWN OF BURKE
AND SUTTON

"The Town of Burke received its charter in 1782 and its first settler arrived in 1792. It was officially organized in 1796 and six generations later, when celebrating its bicentennial, there were still descendants of the original settlers living there.

"The Town of Burke was named for Sir Edmund Burke, a member of British Parliament. The Charter of the Town of Burke granted lands to early settlers who mainly came from Litchfield County, Connecticut. Early settlements were called Burke Green, South Burke, Burke Hollow, East Burke, and West Burke. A prominent feature in Burke is Burke Mountain, which is not closely connected with any mountain range. The wooden tower built on the mountain in 1933 was replaced by a steel tower in 1939 due to much damage done by the hurricane of 1938. It was constructed by the State of Vermont. At one time, there was a Civil Defense post as well as a fire lookout station on Burke Mountain."

The above is taken from *Burke: More Than Just a Mountain*, published in December 1989 by Phyllis Burbank.

This group of young ladies is playing croquet on the front lawn, possibly on Decoration Day or the Fourth of July. (Burke photographs courtesy of Priscilla Aldrich, Burke Town Clerk.)

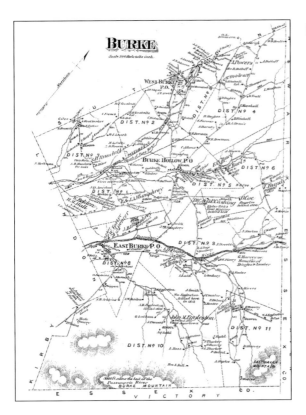

Shown is a map of the town of Burke.

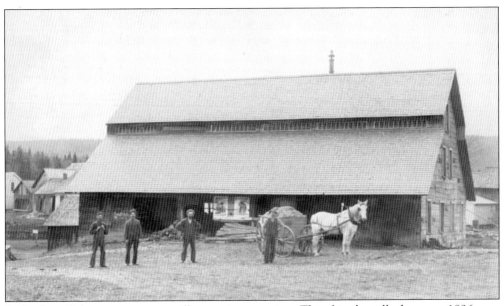

In the late 19th century, many mills were in operation. This shingle mill, shown *c.* 1896, was in West Burke.

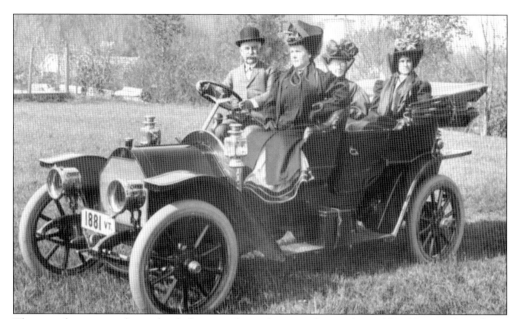

This gentleman is taking the ladies out for a drive in September 1908. Notice their fancy chapeaus. No wonder they needed to fasten them with many pins.

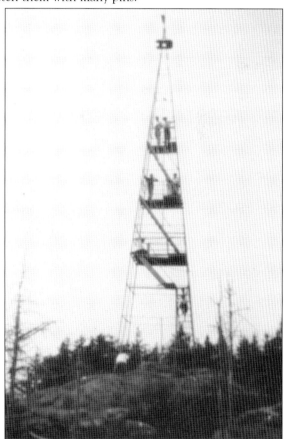

This wooden tower on Burke Mountain was later replaced by a steel tower. It must have swayed in the wind, but there is a fantastic view from up there for those daring enough to climb to the top.

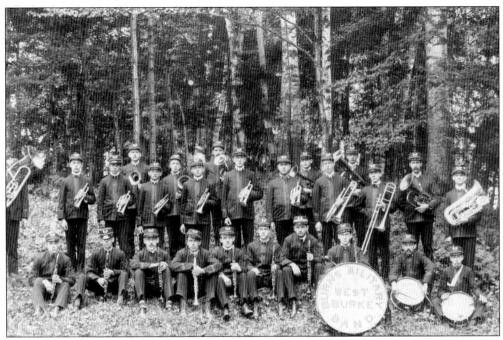

This photograph of the Burns Military Band includes, from left to right, the following: (seated) E. Clark, A. Abar, Ed Lennie, W. Richardson, M. Fairbrother, B. Gray, F. Burns, W. Orcutt, S. Chickering, and E. Roundy; (standing) Ray Blodgett, Fred Woodruff, Burnie Dunn, Dr. Jenkins, Lennie Burns, Frank Woodruff, Ralph Roundy, Ezra Chappell, S. Howland, unidentified, Lyle Smith, Riley Densmore, Ed Craig, B. Crandall, Bert Bishop, and Chas. Nichols.

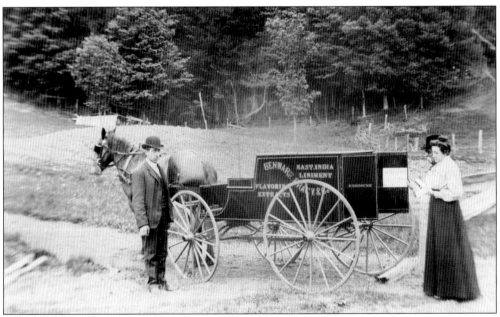

This traveling merchant is George Benware. Henry Turner and an unidentified woman are examining the merchandise.

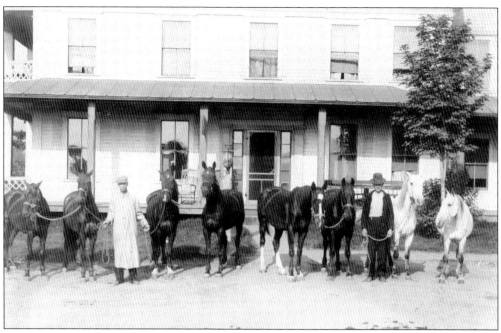

The Trull Hotel once stood in West Burke. Adna Abar's horses are from the livery stable with Pat Smith, *c.* 1914.

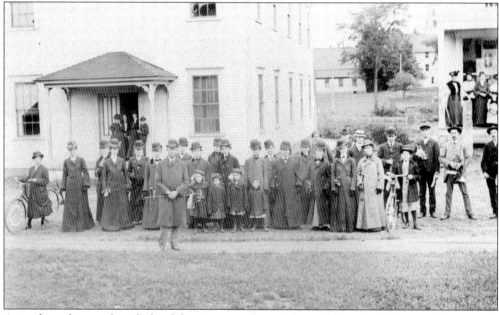

Attending this unidentified celebration are, from left to right, the following: (front row) Blanche Buins (with bicycle), Nellie Ruggles (Waite), Lillian Blodgett, Nellie Gaskell, Mary Fairbrother (Berry), Shirley Hall, Annie Silsby (French), Laura Roundy, Winifred Hickie, Emily Way, Maebelle Vance, and Glenn Round (Attwood); (back row) Mrs. Perry Porter, Mary Packer, Carrie Colby, and three unidentified people; (band) Bill Richardson, Ed Craig, Percy Hall, Frank Buins, Sherman Howland, Harris Colby, and Silas Chickering. In the doorway are Angie Buins, Ida Powers, and one unidentified person.

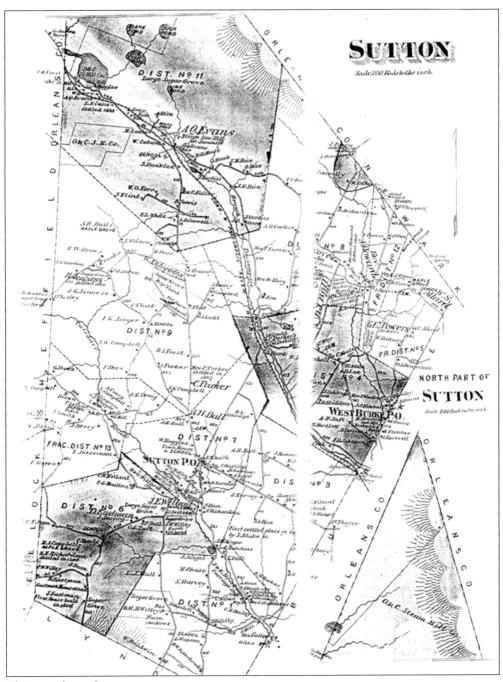

This map shows Sutton.

Sutton

On February 26, 1792, Billymead was chartered by the legislature. Jonathan Arnold and Associates were the original proprietors, and the town was named after his son, Billy. In 1812, the name was changed to Sutton because it was found that Billy was a bully, a drunkard, and a nuisance. The first town clerk was James Cahoon.

Early industries were Brockway's Carriage Manufactory, Alvin Brockway's Carriage and Housepainting Shop (1885), Bundy's Gristmill, Freeman Hyde Sawmill, and S.J. and S.N. Whipple, built by Ward Whipple in 1852. At one time, Dupont Chemicals also mined marl here, which was used in fertilizer. The First Freewill Baptist Church was organized in 1804 with John Colby as its pastor. The present church building was erected in 1832.

The town is located on the height of land between the Connecticut Valley and that of the St. Lawrence. Three branches of the Passumpsic River rise here; other streams flow north. *Child's Gazeteer* (1887) reported a gold and silver deposit in town. At the first town meeting in 1794, James Cahoon was elected town clerk. John Anthony, Samuel Cahoon, and Samuel Orcutt were selectmen, and Jeremiah Washburn served as constable. Other early settlers included the following: Samuel Blake from Moultonboro, New Hampshire; Thomas Colby; Luther Curtis, who came from Swanzey, New Hampshire, c. 1806; James Campbell, a Revolutionary War veteran who hailed from Putney (1806); John Fogg (1810); Josiah Willard (1804); and Asahel Roundy (1821) of Unity, New Hampshire.

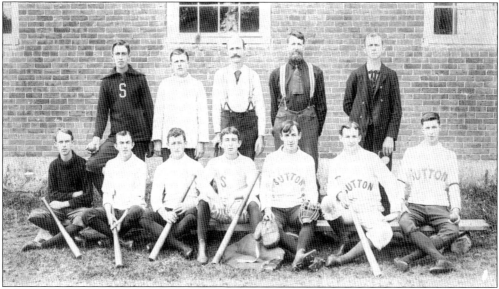

Sports offered a time for recreation. Some members of this Sutton ball team from 1900 are identified. They are, in no particular order, as follows: Harley Byron, Willard Bundy, Lucius Silas, Harris Chickering, John Wilbur, ? Willard, Herman Chapman and George Holtham. (Photographs courtesy of Dorreen Devenger, Sutton Town Clerk.)

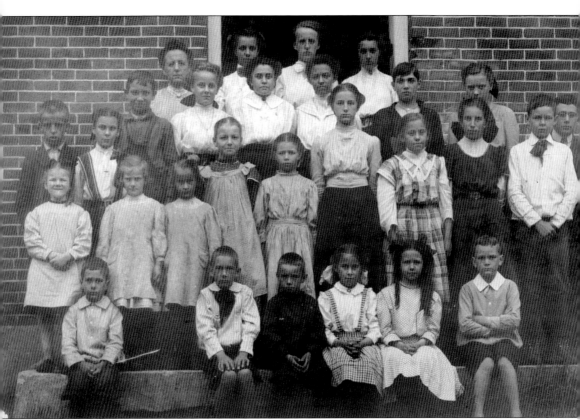

An early school photograph features in the front row, second from the left, Percy Robinson, who later became the town clerk. Also shown, first on the right, is Hartley or Riley Butterfield. The teacher is Sadie Wark.

The blacksmith shop owned by Charlie Aldrich was located across from the Wards House.

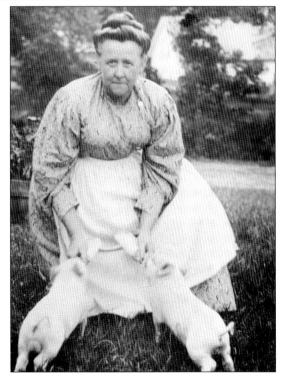

As if women didn't have enough to do, Eva Allard is feeding the piglets.

This early Sutton resident was Harlow Easterbrooks. This picture was taken on December 25, 1905. Notice the horsehair on his coat.

Berrying attire of the day is modeled by Sadie Wark, Fanny Hastings, and Ada Butterfield. They look like they enjoyed this chore.

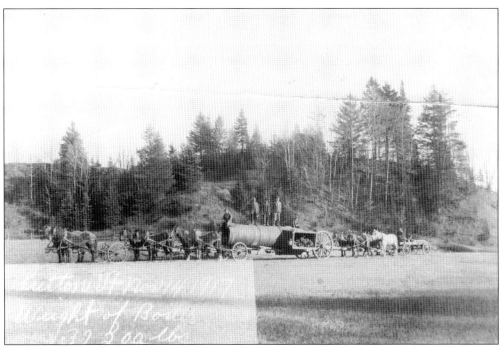

This unusual picture was taken in Sutton on November 14, 1917. The weight of the boiler is listed at 32,200 pounds.

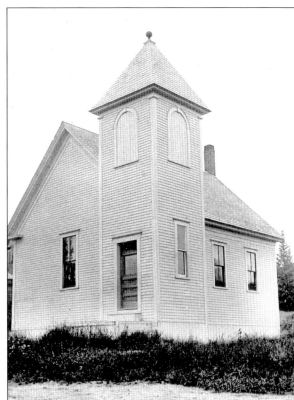

The old Union Meetinghouse is located on the King George Farm, which was formerly called the Clark Farm. This place is now home to the North American Boarding Schools.

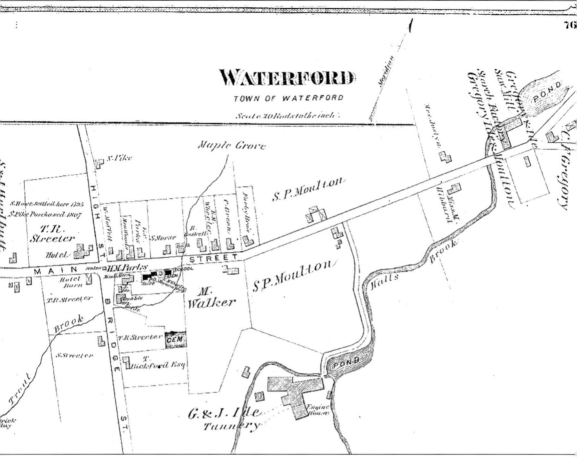

This map shows Waterford.

Nine

WATERFORD

The officers elected at the first town meeting (1793) were the following: Serah Howe (clerk); Peter Sylvester, Daniel Pike, and Nehemiah Hadley (selectmen); Levi Aldrich, Luther Pike, and Levi Goss (listers); Samuel Fletcher (constable); and Abel Goss (treasurer). Daniel and Nathan Pike, Jonathan Hutchinson, and Luther Knight arrived from Royalston, Massachusetts, in 1792 and settled in the eastern part of Waterford. Sawmills were built by Solomon Pomeroy in the Upper Village and by John Stiles at the outlet of the pond that bears his name (1807).

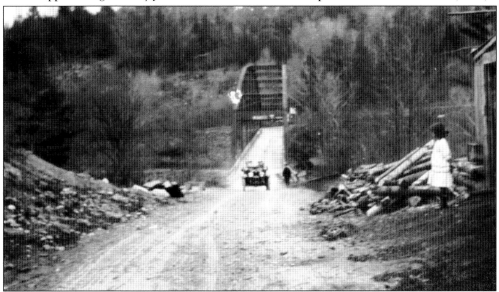

This is the Upper Waterford bridge in the late 1920s. Fontelle Perkins collected tolls on the bridge. (Waterford pictures courtesy of the Waterford town clerk, Mrs. Patricia Powers, and Mrs. Dorothy Morrison.)

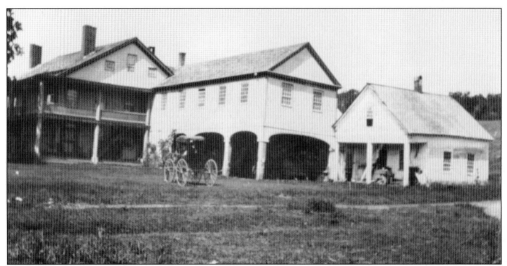

These photographs show the interior and exterior of the Pike-Streeter Hotel and Tavern, located in Waterford. In 1823, Nathan and Dennis Pike decided to convert their small farmhouse, which stood at the crossroads in the village, into a tavern. They accomplished this by building onto and over it, without tearing it down. To the right of the front hall was the barroom, decorated with a beamed ceiling and dark woodwork. The rear of this room was partitioned off to provide space for the bar, a cellar stairway, and a passageway to the kitchen. There was a wooden grill that could be lowered to separate the bar from the rest of the room, and cupboards with glass doors housed liquor supplies and tumblers. (This was where Miss Streeter kept the books when she had charge of the Waterford Library.) A nook under the stairway opened into the barroom and was the private domain of the hostler. They ran the tavern for many years, but it was sold in 1864 to Timothy Streeter, a native of Concord.

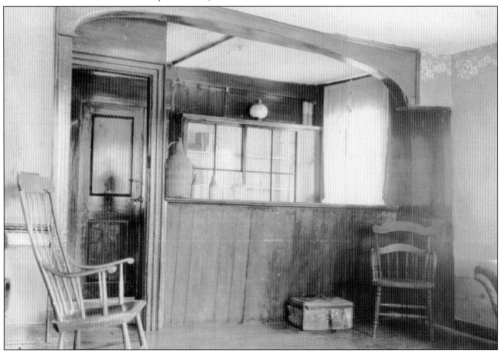

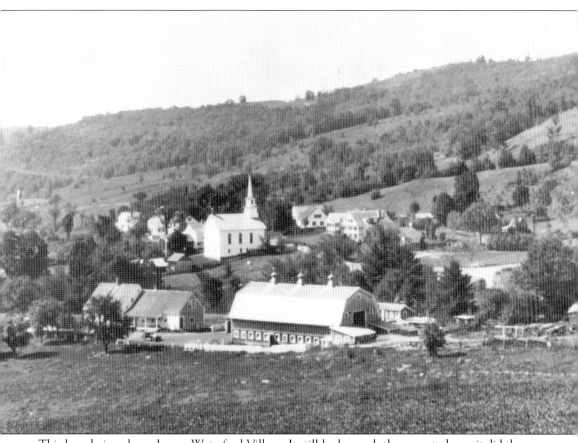

This broad view shows Lower Waterford Village. It still looks much the same today as it did then.

From 1954 to 1980, Dorothy Morrison filled the position of postmaster in this post office building in Waterford. The office was located in the room that had previously been the kitchen. Annie Morrison, Dorothy's mother-in-law, was also postmaster from *c.* 1918 until her death in 1944.

Mr. and Mrs. Ernest Powers held various positions in the town and were honored for their 40 years of service, from 1918 to 1958.

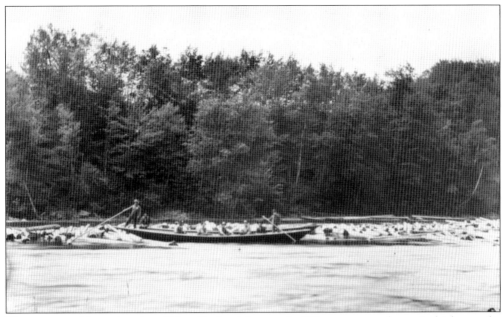

The rivers and large brooks of New England for nearly 100 years were the main highways for the transportation of timber. The first lumber that was sawn was rafted in May 1851. During the winter, gangs of men cut the tall majestic pine and spruce. They had scores of strong, rugged horses to haul the logs to skidways on the river. In the early days, oxen were used for that purpose, but they gave way to the horse as they were more active and much more timber could be hauled in the same length of time. Every winter, 10 to 20 million feet of lumber were cut. The logs varied from 30 to 70 feet in length and were from 10 to 40 inches in diameter. In the spring, when the logs were rolled into the stream, a gang of rough and hearty men with hob-nailed boots on to help them walk the timber without slipping, armed with a peavey, had to go along to see that the logs kept afloat. These gangs were designated "rivermen" and were the most hardy, tough, and rugged physical specimens of mankind that it would be possible to find anywhere.

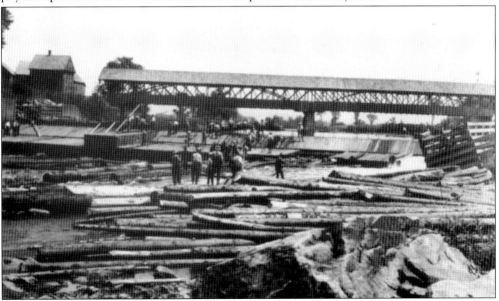

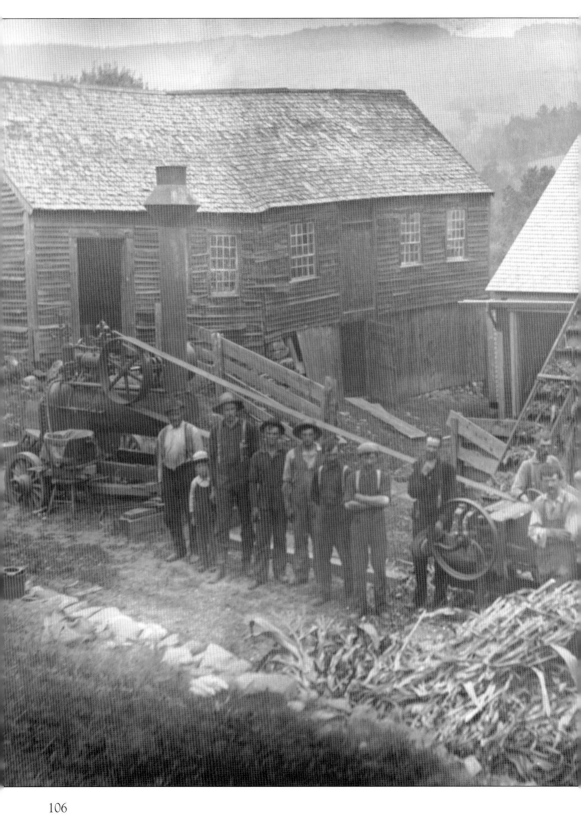

The Francis Carpenter
farm using horsepower
for producing their
corn silage makes an
interesting picture.

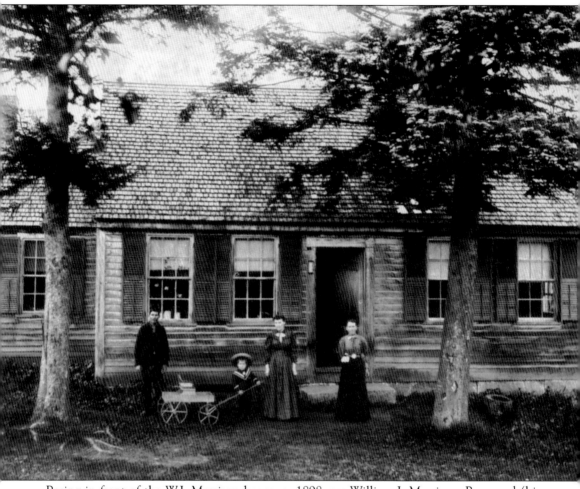

Posing in front of the W.J. Morrison house, *c.* 1898, are William J. Morrison, Raymond (his oldest son), his wife, Annie, and his sister, Emma.

Ten

PEACHAM

In 1763, David Smith and 69 associates of Hadley, Massachusetts, received a charter from Benning Wentworth, governor of New Hampshire, naming them proprietors of the township of Peacham, comprising 23,040 acres. This hilly, picturesque village was once covered with dense forests. A few peaks are above 2,000 feet, such as Devil Hill and Cow Hill, where views of the Green Mountains and White Mountains can be seen. Onion River, Ewell's, Martin's, and Foster's Ponds are the prominent ponds in Peacham.

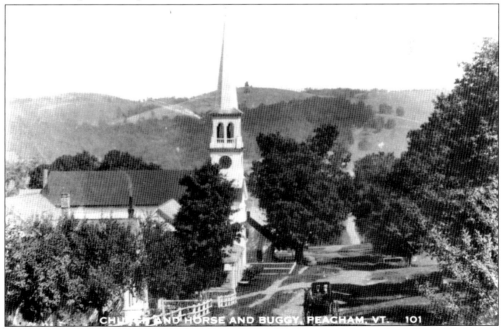

This church is located in the town of Peacham. It was moved down the hill in 1844 to its present location. (Peacham photographs supplied for a fee by the Peacham Historical Society.)

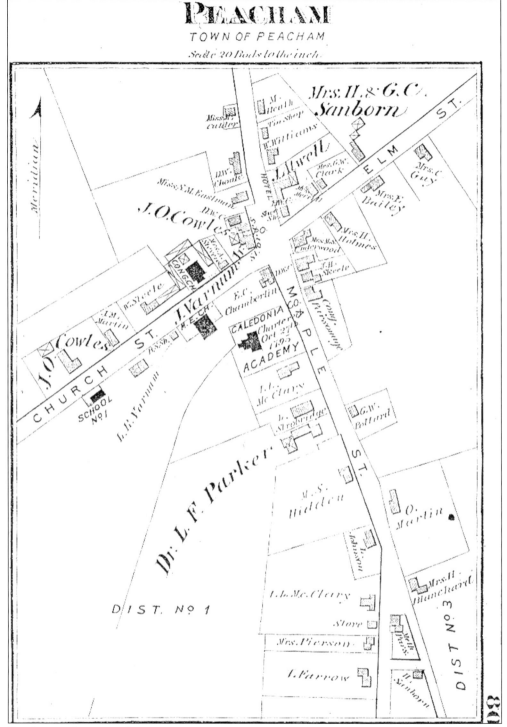

Peacham is shown on this map.

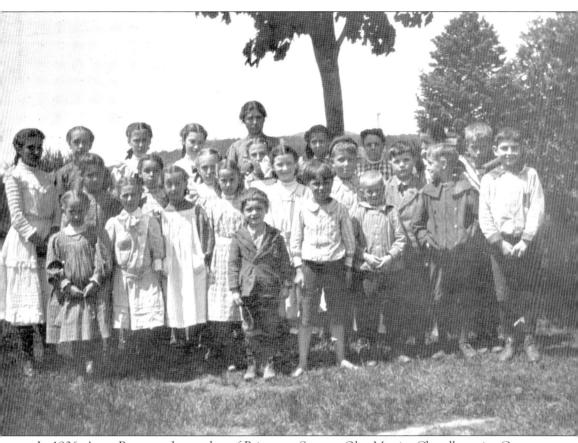

In 1906, Anna Rast was the teacher of Britomart Somers, Olga Martin, Chandler twins Gwen and Geneva, Harriet Jennison, Arlene Jennison, Will Gracey, Matt Gracey, Henry Gilfillan, Eaton McLaren, James Allen, and David Wilson.

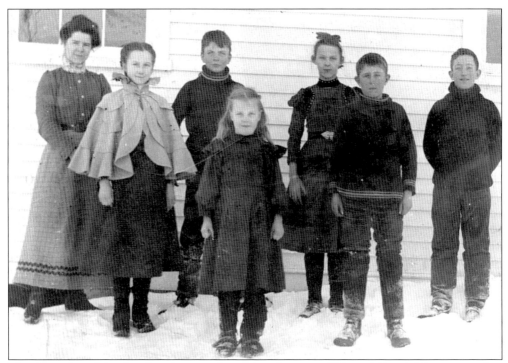

The Green Bay School in Peacham was located in the area of Martin's Pond. This was teacher Maud Guthire's first school, *c.* 1900. It received its name from someone who thought it reminded them of Green Bay, Wisconsin.

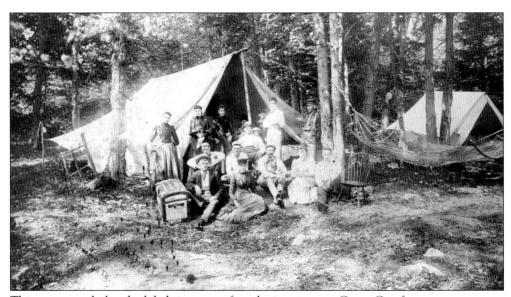

This group regularly scheduled time away for relaxing times at Camp Comfort.

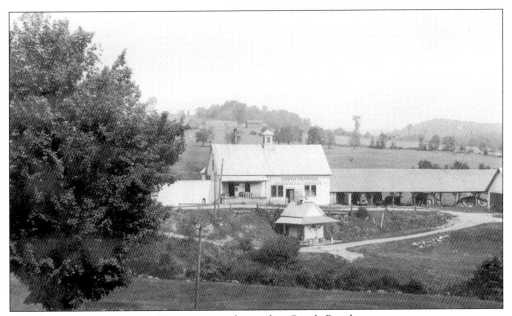

The Cooperative Creamery Company was located in South Peacham.

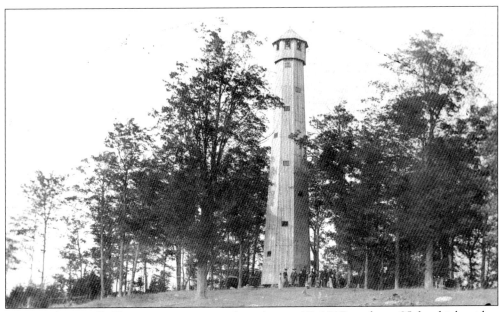

The Academy Hill Observatory was erected on August 17, 1897, and was 85 feet high with a 16-foot base.

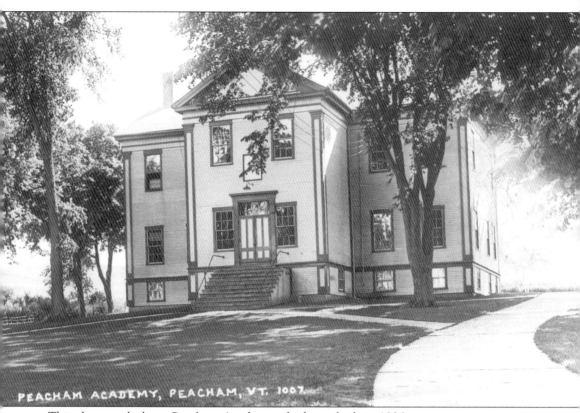

PEACHAM ACADEMY, PEACHAM, VT. 1007.

This photograph shows Peacham Academy, which was built in 1806.

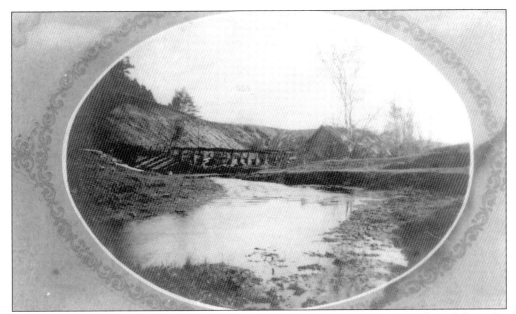

This view shows the Ewell's Hollow gristmill and flume in 1900. The water flowed from the end of the flume into a penstock with a drop of 15 feet. The water turned the stone wheels that ground the corn, wheat, barley, and oats into feed for the cattle and horses. Wheat was also ground into flour. There was a blacksmith shop where the oxen and horses were shoed.

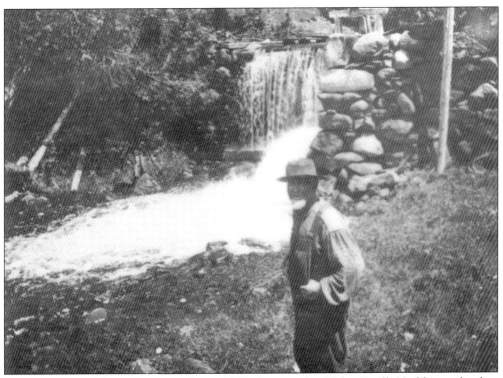

The Ewell's Pond dam appears in this *c.* 1900 photograph of John Ewell. Visible are the dam and gate used to operate the flow of water at Ewell's Pond.

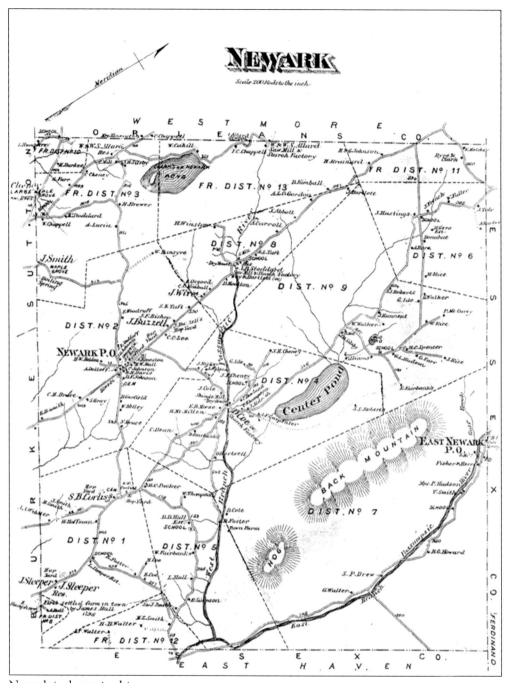

Newark is shown in this map.

Eleven

NEWARK AND KIRBY

Newark

On August 15, 1781, Newark was chartered to William Wall and 64 others. Before that, it was a wilderness that George II of England granted to the governor of New Hampshire, Benning Wentworth, along with Arnold Ball, Eleazar Packer, Charles Palmer, and Timothy Hartwell. Miles Coe was the first constable, and David Pike was the first treasurer. In 1795, land was first cleared near the Burke border, and James Ball settled here two years later. In 1809, the town of Newark was officially organized; the first selectmen were Eleazar Packer, James Ball, and John Sleeper. (Newark photographs courtesy of Myron Corliss.)

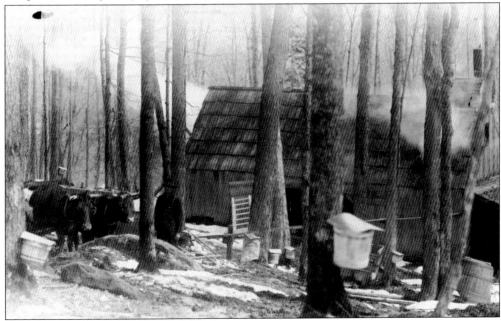

Earl Swett is shown sugaring with covered sap buckets and oxen in a Mr. Coe's sugar orchard.

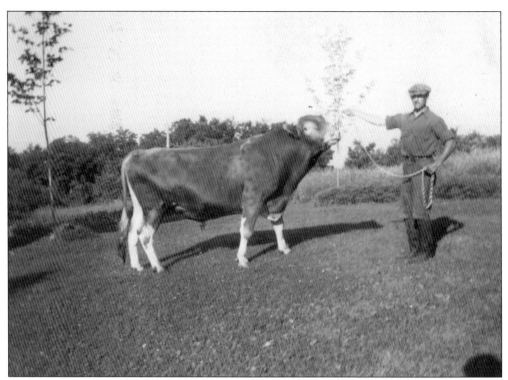

Merton Corliss poses with a bull. He was a dairy farmer and sugar maker from 1930 until 1958, when he sold his dairy cattle and stopped farming due to poor health.

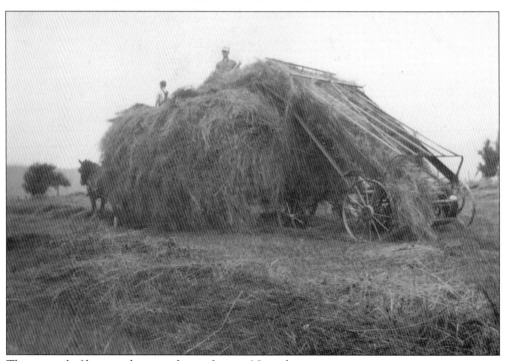

This mound of hay was harvested on a farm in Newark.

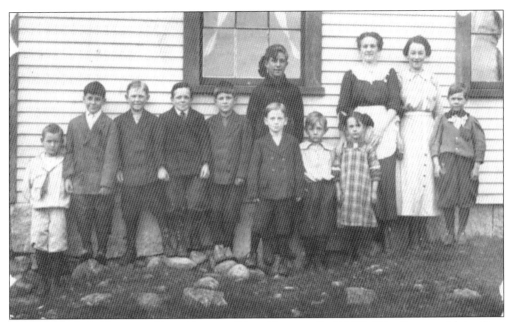

These school children are Chase Damon, Edgar Damon, Basil Hill, Fritz Farmer, Alvin Coe, Fenton Damon, Alton Hill, Leighton Swett, Marion Swett, Dorothy LaRoche (teacher), Maude Coe, and Cecil Melville. The photograph was taken June 6, 1913.

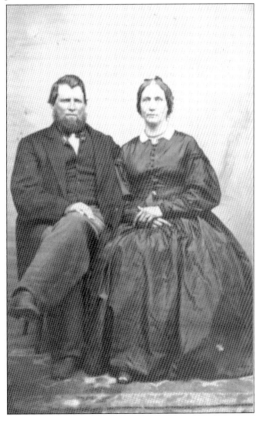

Shown are Jabez and Sophronia Smith, an early couple in Newark.

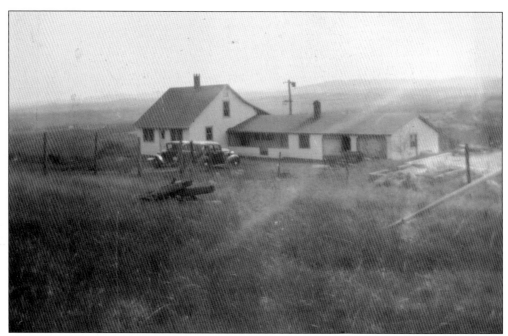

The original house located on this site was occupied by the Smith and Ham families for more than 100 years. After it was destroyed by fire on April 12, 1945, Lawrence and Lois (Ham) Baird rebuilt it in 1946.

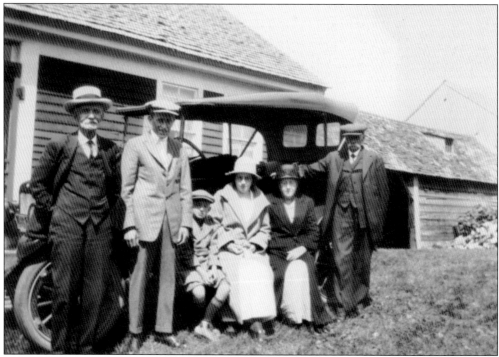

Joining the Ham family for a visit in Newark is Graham Newell as a boy, c. 1910. Pictured, from left to right, are Cortis Berry, Alston F.C. Ham, Graham Newell, Maude (Berry) Newell, (Cortis's daughter), Mary "Lizzie" (Smith) Ham, and Myron Ham (Alston's father).

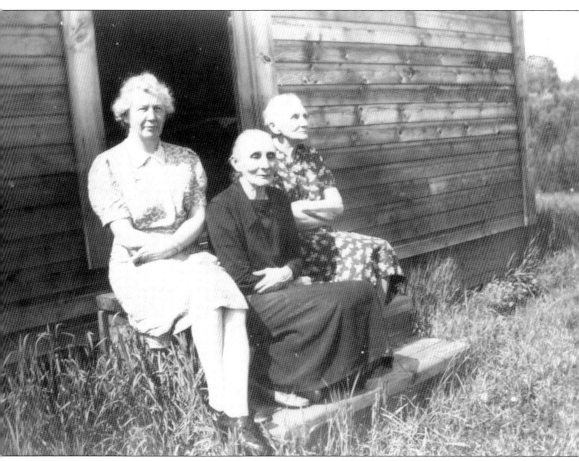

These three ladies are Ruby (George) Corliss of Newark, her sister, Almina "Miney" (George) Davis, and Euphemia (Jewett) Austin.

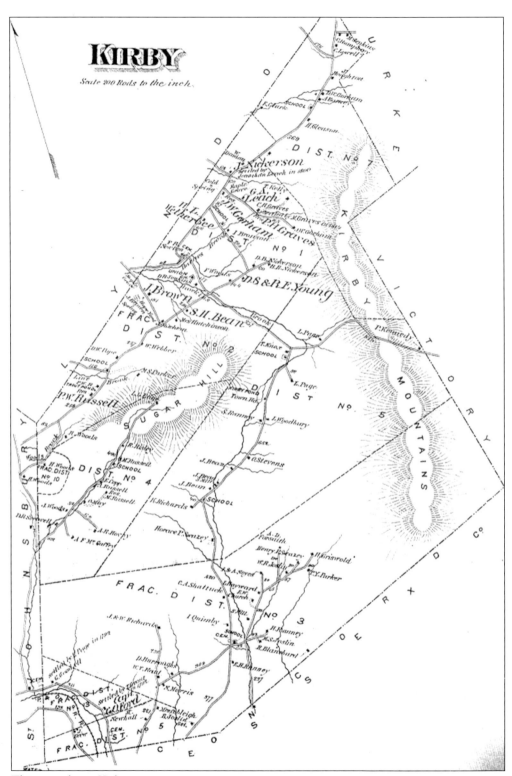

This map shows Kirby.

122

Kirby

Not long after Jonathan Leach had made his first "pitch," he was forced, because of a redrawing of the lot numbers, to start a new one several miles away. Despite the major problem of clearing a second area and preparing to till it, he raised enough grain the first year to satisfy the needs of a family of four. The second year, with only manpower, he raised 150 bushels of wheat. The third year, he erected a frame barn, which also served as the first schoolhouse and was the site of the first religious meeting. Leach built the first sawmill in Kirby. (Kirby photographs courtesy of Virginia Wood and Albert and Polly Taylor.)

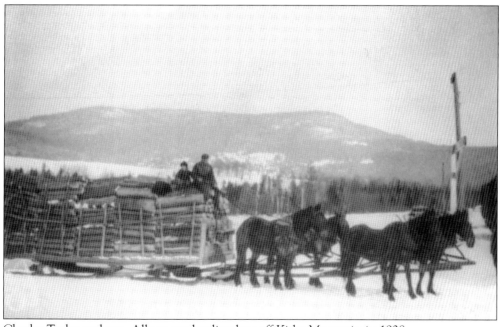

Charles Taylor and son, Albert, are hauling logs off Kirby Mountain in 1928.

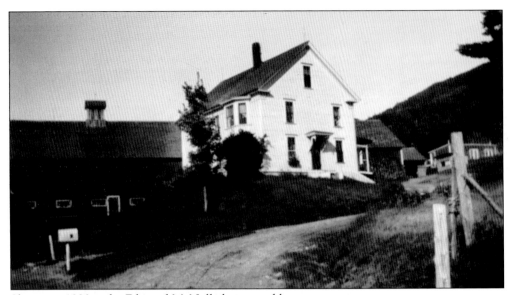

Shown in 1930 is the Edmund McNally house and barn.

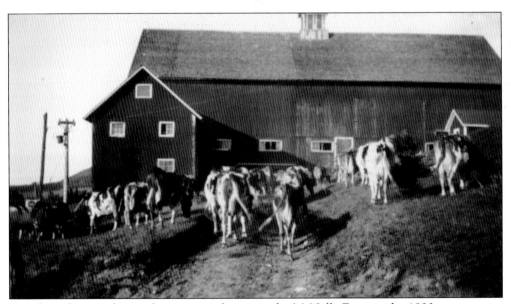

Somehow the cows knew when to come home on the McNally Farm in the 1930s.

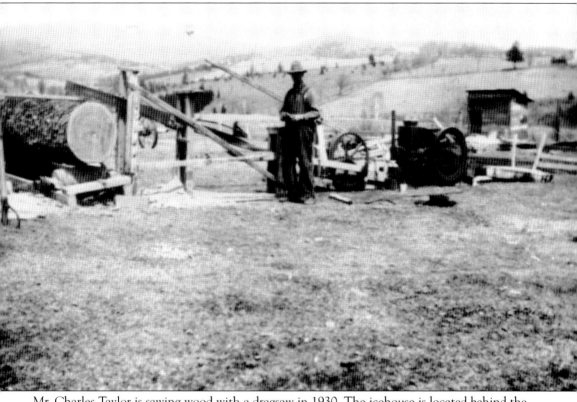

Mr. Charles Taylor is sawing wood with a dragsaw in 1930. The icehouse is located behind the saw, as it was customary to pack the ice in sawdust.

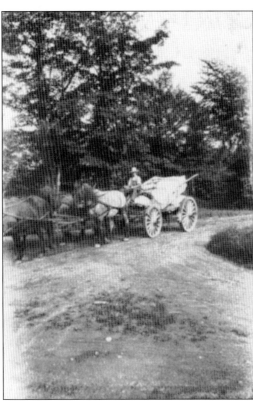

Hauling granite from the Kirby Quarry to the Concord granite sheds is Charles W. Taylor, *c.* 1928.

This four-horse team is working hard at removing granite from Kirby Mountain.

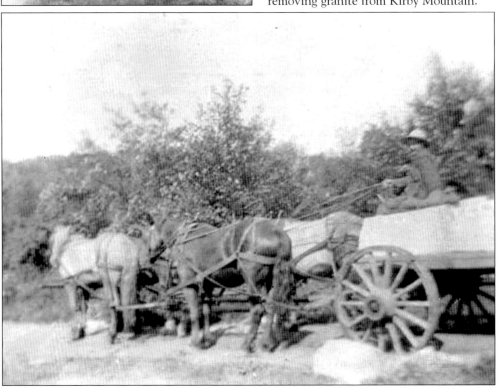

This farm has been in the Taylor family since 1865. The original house and barn were built in 1820 and burned in 1920. Today, it is occupied by Albert and Polly Taylor.

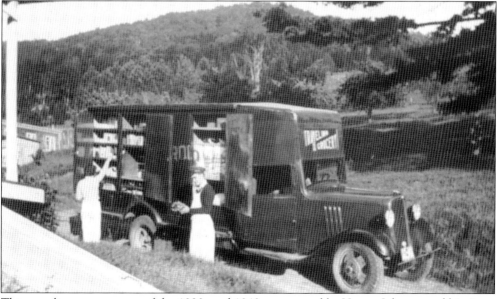

This traveling grocery store of the 1930s and 1940s was owned by Homer Johnson and his sister.

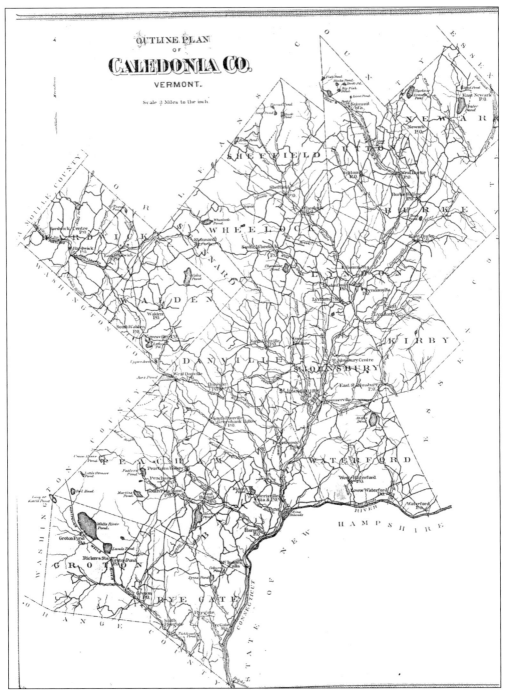

This map shows Caledonia County c. 1875.